1/04

This book was donated
to honor
the birthday of

Susan Hackett

by

Winnie Waltzer Hackett
Kirk Hackett
2004

DATE

Colored Pencil Explorations

Colored Pencil
EXPLORATIONS

JANIE GILDOW

NORTH LIGHT BOOKS
CINCINNATI, OHIO
www.artistsnetwork.com

DEDICATION

This book is dedicated to all artists who wish to extend their horizons and specifically to the many who have requested a book that would show them how to combine colored pencil with other media.

ACKNOWLEDGMENTS

I extend my sincere thanks to the talented artists who contributed their art and expertise to the pages of this book—especially to the demo artists who during their busy schedules put up with me asking for things. I have the utmost respect for all of them.

Very special thanks go to Jennifer Lepore Kardux, my excellent (and patient) editor and best of all, my friend.

My thanks to Rachel Wolf for sharing my vision and my gratitude to North Light for their appreciation of the colored pencil as a viable medium.

Heartfelt thanks to my husband, Joe, who continues to deserve sainthood. His support and patience have made it possible for me to write this book.

Continued thanks to Dina Cooper, Harold Crick, and the Sanford Corporation; Helen, Elizabeth and Jane Holt of The Artist in You, Green Valley, Arizona; Lynn Pearl and ColArt USA; Glenn Brill and Savoir-Faire; Craig Kennedy and Createx Colors; Mary Findysz and Photographic Works, Tucson, Arizona; Fred Soto and Sarnoff Art & Writing Supplies, Tucson, Arizona.

Colored Pencil Explorations. Copyright © 2003 by Janie Gildow. Manufactured in China. All rights reserved. No part of this book may be reproduced in any form or by any electronic or mechanical means including information storage and retrieval systems without permission in writing from the publisher, except by a reviewer, who may quote brief passages in a review. Published by North Light Books, an imprint of F&W Publications, Inc., 4700 East Galbraith Road, Cincinnati, Ohio 45236. (800) 289-0963. First edition.

Other fine North Light Books are available from your local bookstore, art supply store or direct from the publisher.

07 06 05 04 03 5 4 3 2 1

Library of Congress Cataloging-in-Publication Data
Gildow, Janie
 Colored pencil explorations / by Janie Gildow.—1st ed.
 p. cm.
 Includes index.
 ISBN 1-58180-186-6 (hc. : alk. paper)
 1. Colored pencil drawing—Technique. I. Title.

NC892.G545 2002
741.2'4—dc21 2002071855

Edited by Jennifer Lepore Kardux
Cover designed by Lisa Buchanan
Interior designed by Wendy Dunning
Interior production by Joni DiLuca
Production by Mark Griffin

Cover art: *Variation(s)*, Janie Gildow, CPSA, 12" x 16" (30cm x 41cm), Colored pencil and pastel; *Golden Lily*, Kristy A. Kutch, CPSA (see page 49); *Gold Hill Tapestry*, Dyanne Locati, CPSA (see page 63); *Matanzas Sky*, Priscilla Humay, CPSA (see page 67); front flap: *Signs of Life*, Barbara Benedetti Newton, CPSA (see page 69)
Art on pages 2-3: *And Then There Were 3*, Janie Gildow, CPSA, 11" x 15" (28cm x 38cm), Colored pencil and acrylic; *Sun Kissed*, Sueellen Ross (see page 68); *Signs of Life*, Barbara Benedetti Newton, CPSA (see page 69)

Page 140 constitutes an extension of this copyright page.

The line drawings on pages 132-137 have been created so you can practice using your colored pencils along with the demonstrations in this book. Please feel free to copy and enlarge these drawings for this purpose.

METRIC CONVERSION CHART

to convert	to	multiply by
Inches	Centimeters	2.54
Centimeters	Inches	0.4
Feet	Centimeters	30.5
Centimeters	Feet	0.03
Yards	Meters	0.9
Meters	Yards	1.1
Sq. Inches	Sq. Centimeters	6.45
Sq. Centimeters	Sq. Inches	0.16
Sq. Feet	Sq. Meters	0.09
Sq. Meters	Sq. Feet	10.8
Sq. Yards	Sq. Meters	0.8
Sq. Meters	Sq. Yards	1.2
Pounds	Kilograms	0.45
Kilograms	Pounds	2.2
Ounces	Grams	28.3
Grams	Ounces	0.035

ABOUT THE AUTHOR

Janie Gildow is a graduate of the Ohio State University and a member of Kappa Kappa Gamma Sorority with a bachelor of Science in art education.

After a career as an art instructor in the public schools, Janie is now a full-time professional artist.

She is coauthor (with Barbara Benedetti Newton) of the *Colored Pencil Solution Book* (North Light Books, 2000).

Her award-winning work has been published in *The Artist's Magazine*, *American Artist*, *International Artist*, and in many books and publications (including *The Best of Colored Pencil 2, 3, 4* and *5* from Rockport Books).

Janie teaches workshops and judges art exhibitions throughout the United States. She is available to present the colored pencil to any group, including high school and college students.

Janie is a Signature Member of the Colored Pencil Society of America (CPSA) and holds its 5-Year Award. She is a juried member of the Catherine Lorillard Wolfe Art Club, New York.

In yet another capacity, Janie served as CPSA Membership Director from 2000-2001 and currently serves on the CPSA National Board as an Honorary Director.

Janie appears in *Who's Who of American Women*, *The World Who's Who of Women* and the *International Who's Who of Professional and Business Women*.

You can find her art in several places on the World Wide Web. Please visit her Web site at http://www.janiegildow.com.

Janie's art instruction and expertise is available in a Prismacolor Project Kit (Still Life series) on sale at art and craft stores.

Janie currently resides in sunny Arizona with her husband and their two cats—Bentley and Murfee.

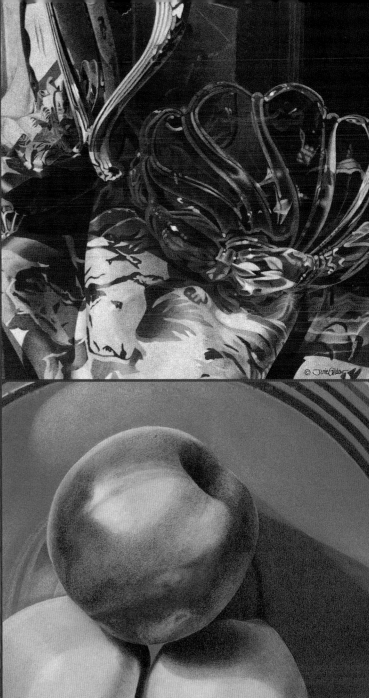

CHAPTER FOUR
CREATIVE EFFECTS
With Colored Pencil
page 74

CHAPTER FIVE
CREATIVE TECHNIQUES AND SURFACES
for Colored Pencil

page 102

Colored pencil can be an end in itself. Sure, it's possible to pick up a set of colored pencils and make a piece of art that looks totally finished—like a painting. But what if your soul cries out for something more? What about colored pencil and something else? This book is for those of you who hunger for more.

The very nature of the wax-based pencil makes it the perfect medium for combining with other materials and processes. Colored pencil is perfect for making marks on all kinds of dry surfaces and mediums. It *sticks* to anything that's not slippery, wet or shiny. It adds a special luminescence when applied over watercolor. It lends brilliance and depth to pastel. It slides over vellum, smooths its way over ink, and even adheres to acrylic. Its effects change with every application to each new medium and surface.

This book introduces you to different mediums and shows you how well they partner with the colored pencil. Follow along step by step with well-known artists as they show you exactly how they work. See how they combine colored pencil with other mediums to augment and enrich their work.

Apply color with a brush, spray it on with an airbrush, rub it on with your fingers. Dissolve pigment with solvents. See how different surfaces affect the color and application of various combinations of mediums. Experience the luscious combinations of color and texture possible to you. Stoke up your creative fires. Experiment!

Use the colored pencil as you've never used it before—to express yourself, to make music, to set yourself free and to soar.

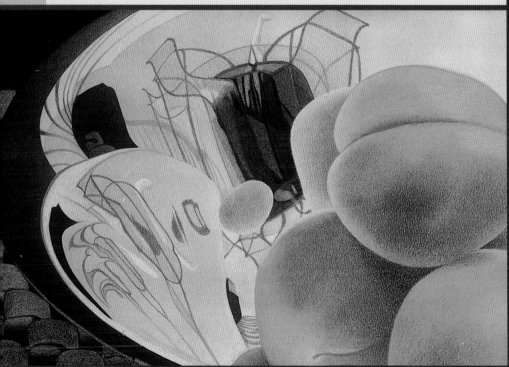

SILVER AND VELVET (detail) | Janie Gildow, CPSA | 11" x 16" (28cm x 41cm) | Colored pencil and airbrushed acrylic on black LetraMax board | Private collection

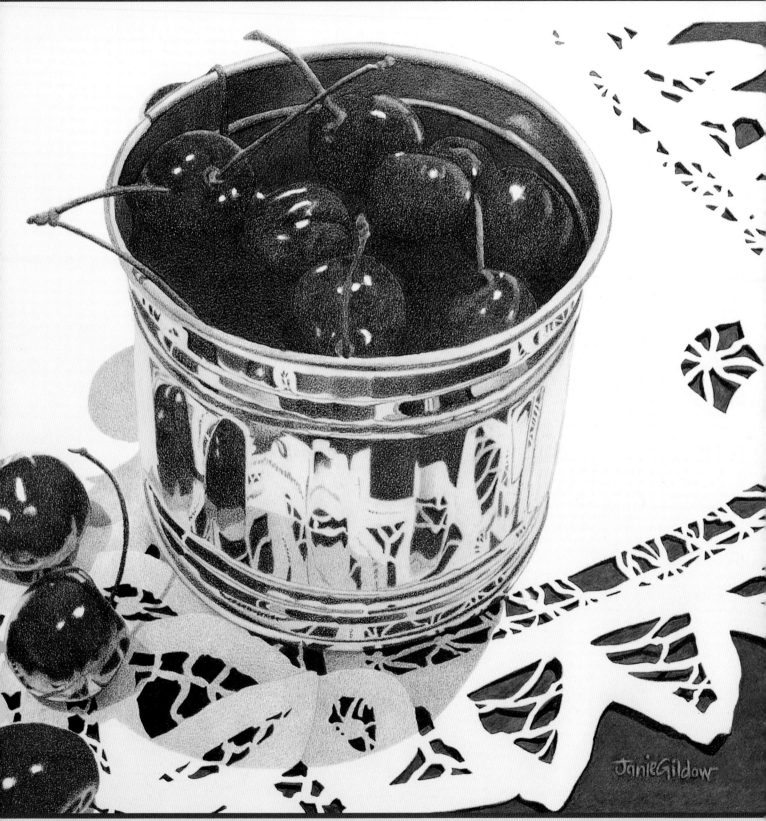

SECRETS | Janie Gildow, CPSA | 8" x 11" (20cm x 28cm) | Colored pencil, water-soluble pencil, ink and acrylic on 140-lb. (300gsm) hot-pressed watercolor paper | Collection of the artist

Get acquainted with colored pencils. Colored pencils are fun—lots of juicy color, no mess, no noxious fumes, and (the best part) no cleanup. When you're ready to work, they're ready. When you have to stop, you just put your pencil down. When you want to start again just pick up a pencil and go from where you left off. Work for five minutes or an hour, it doesn't matter. Start and stop whenever you want.

Colored pencils are versatile. Even when used alone and not in combination with any other mediums, they are capable of creating many unique and exciting effects.

In this chapter you'll learn the basics. You'll find out how colored pencils are made, what to expect from the different brands, and how to get the most from your pencils. You'll be introduced to the minimal tools and equipment you need to get started. You'll explore different techniques and application methods and discover what works best for you.

Don't wait any longer. Turn the page and start on your journey through the wonderful world of the colored pencil right now!

CHAPTER ONE

The COLORED PENCIL

NEXUS | Janie Gildow, CPSA | 18" x 14" (46cm x 36cm) | Colored pencil on black LetraMax board | Collection of the artist

How the Colored Pencil Is Made

Early man expressed himself with his drawing tools. Over the years drawing tools have been modified, refined and reinvented. The pencil has evolved from a piece of colored rock or a charred stick to today's myriad offerings. The pencil's function is to encase the "part that marks" and keep it from getting all over your hand as you use it. Just walk through an art store or office supply store to enjoy all the variations.

It's fascinating to look at how the colored pencil is made—from its separate ingredients and elements to the finished product, boxed and ready for the retail shelves.

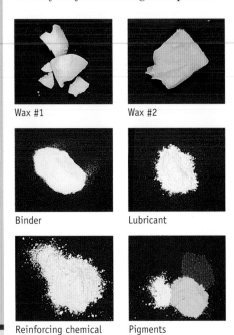

Wax #1 Wax #2

Binder Lubricant

Reinforcing chemical Pigments

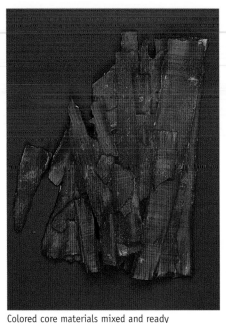

Colored core materials mixed and ready for extrusion

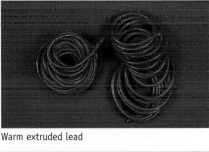

Warm extruded lead

Rods dried and ready for insertion

Colored "Lead" Ingredients

Colored "lead" is made of more than just wax and pigment. It takes a chemist to combine the materials necessary to produce a durable lead with the properties that make it usable and desirable to you. And it's not a simple process. Many things must be taken into consideration including pigment availability, lightfastness, hardness/softness, color consistency, lay-down characteristics, marketability and color trends.

Making the Pencil "Lead"

The dry ingredients are measured and blended together in a big mixer (actually a commercial dough mixer) and after approximately fifteen minutes, water is added. The waxes are heated together until they melt and the molten wax is added to the color mix, which is then blended for four to six hours.

Sometimes less than 1 percent of one of the pigments is needed to tint the color mix. It still must be evenly dispersed throughout the 350-lb. (159kg) batch so the mixing has to be thorough and takes longer. At completion, the mixture closely resembles dough.

The "dough" (core material) is taken out of the mixer and put through a two-roll mill that disperses the pigment even more. The resulting pieces are like paper—thin and flat.

The rolled core material is then put through a press and extruded as rods. The rods are still warm and the wax is still pliable so that at this point the rods can be bent and curled.

The rods are then air dried in rotating dryers in a dehumidified and climate-controlled room for five days before they're ready to be encased.

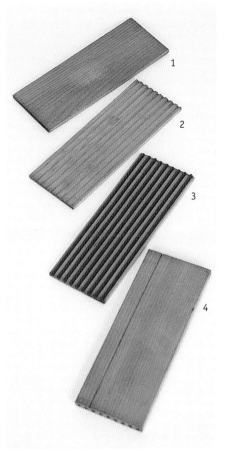

Making the Pencil

Once the pencil lead rods have dried, they're ready to be encased in wood.

Cedar is cut into pencil-length slats (1), and then grooved to match the width of the lead rods (2).

The colored leads are then glued into the grooves (3) and another grooved slat is placed over the rods and glued in place like a sandwich. Then the slats are sanded to a consistent length (4).

The glued sandwich is then cut into individual rounded pencils (5).

The separated pencils move through a machine that paints them the proper color and imprints the pencils with a gold name, color and number (6).

Brands and Characteristics

Comparing Major Brands

Experiment with different brands of pencils to discover which ones exhibit the qualities that work best for you. Every brand of pencil is different in both appearance and characteristics. Some pencils are round, some hexagonal. Some are finished on one end. Leads vary from soft to hard, and thin to thick.

Pencils sold in open stock are perfect for experimenting because you don't have to buy a whole set—you can purchase just one or two pencils at a time.

Buy the best pencils you can afford. Some pencils are for school students and some are just for coloring maps, but others are for fine artists and are higher in quality and performance. Price usually points the way. Like most things, you pretty much get what you pay for and pencils that deliver better just plain cost more.

If you aren't familiar with colored pencils, begin with Prismacolor. These pencils are top-of-the-line and a good way to get you acquainted with what colored pencils can do. They are round with both ends unfinished. The leads are buttery soft and loaded with color. They have a marvelous capacity to lay down well when one color is layered over another.

If you want your pencil to hold more of a point as you burnish, and/or you normally use quite a bit of pressure as you apply color, you might want to look into purchasing one of the harder brands—Polychromos (medium hard) or Derwent Artists (hard).

Lightfast Issues

Colored pencil manufacturers are working to make pencils lightfast—as impervious to ultraviolet light as possible and resistant to fading.

There are several things that you can do to make your pencils, and art, more lightfast. Just by layering one pencil over another you can make color more lightfast. Spraying your work with a fixative that screens out ultraviolet light also helps. Framing your art with glass or acrylic adds yet another layer of protection. And, never hang your work in direct sunlight.

Handle Pencils With Care

You need to give your pencils plenty of tender loving care. Lead can break inside pencils that are dropped on a hard surface. You'll discover it to your very great dismay as you try to sharpen a pencil that has been dropped. The point just keeps breaking off inside the sharpener and your pencil gets shorter and shorter.

Pencils aren't meant for rough handling or hard pressure. If your pencils tend to break often, think back to whether or not they could have been dropped, or look at how you apply color. If you press too hard, it's easy to break a lead. I keep my pencils very sharp and sharpen them often so I handle them gently.

Color Variety

As you use colored pencils, you'll quickly discover that you have to be inventive in order to develop certain colors—because all the colors you need certainly aren't going to be available even in the largest set of pencils. But it's nice that Prismacolor pencils are available in such a large color palette so that you can approximate the color you want more easily to begin with. Then you don't have to do as much layering to achieve it.

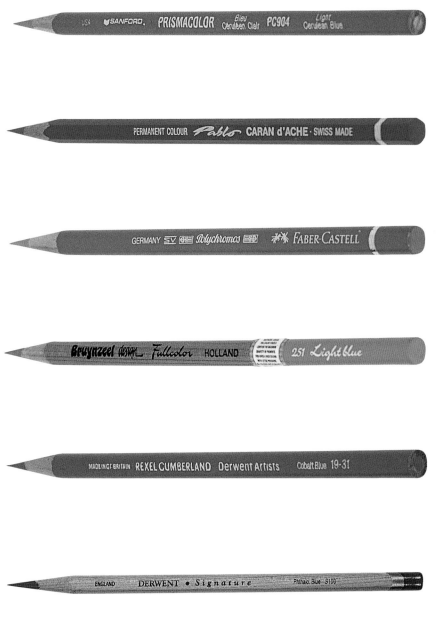

Prismacolor (Sanford)

Round pencil, both ends unfinished, soft lead. Excellent for layering. Available nearly everywhere. Thick buttery lead. 120 colors.

Pablo (Caran d'Ache)

Hexagonal shape, one end finished, soft lead. Excellent for layering. Not available everywhere. Very finely crafted pencils. 120 colors.

Polychromos (Faber-Castell)

Round shape, one end finished, medium-hard lead. Unique lay-down quality, ability to hold a point and large color palette give this group its popularity. 120 colors.

Fullcolor (Bruynzeel)

Round shape, one end finished, medium-hard lead. Some artists prefer these pencils for their unique and brilliant color; however, they are not sold everywhere and some leads tend to splinter. 100 colors.

Derwent Artists (Rexel Cumberland)

Round shape, both ends unfinished. Hardest of the major brands, these pencils are excellent for burnishing. Larger diameter makes sharpening difficult with some sharpeners. 120 colors.

Derwent Artists Signature Lightfast

Round shape, one end finished. This new line of pencils is reputed to be of the highest level of lightfastness. The leads are softer than other Derwents; the pencils tend to feel dry and drag a bit during application. Larger diameter makes sharpening difficult with some sharpeners. 60 colors.

Tools and Equipment

One of the real pleasures of working with the colored pencil is the lack of mess and bother. Pencils are safe to use (though not meant to be eaten) and you don't need a lot of expensive tools and equipment to make them work. It nearly boils down to having a set of pencils and a pencil sharpener, but not quite. There are some other things to consider.

Your Work Space

Drawing Surface

Find a place where you have a flat surface to draw on, whether it's an adjustable drawing table or just a table. You can always tape your work to a drawing board or piece of heavy cardboard and then put it away somewhere when you aren't working on it.

Chair

Try to find a comfortable chair that supports your back. You may find you've been sitting in one position for quite a long time, and a good chair prevents fatigue and helps your posture.

Lights

Get lots of light. If you can find a spectrum-balanced light, that's best. White light from the sun contains all the colors of the spectrum equally balanced. Spectrum-balanced lights closely reproduce white light, and allow you to work at night if you want. With them you'll see true and natural color.

Being near a window always helps. One with a northern exposure gives the best and most consistent light. Now I have to admit that I don't always follow my own advice—especially when it comes to windows. I'd much rather be near a south-facing window because I'm really a day person and love sunlight. But I never let the sun shine directly on my work or my drawing board.

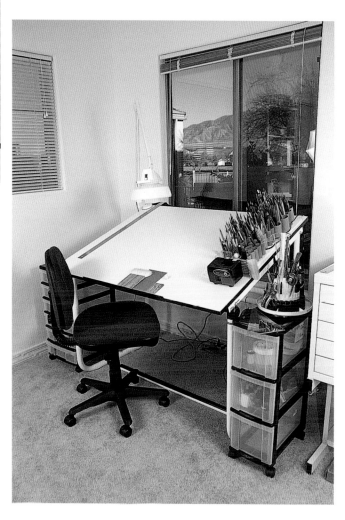

Drawing Table and Work Area

My drawing table has adjustable height and slant, and my chair gives me good back support. I have a spectrum-balanced light that clips to the drawing table. The rolling drawers (inexpensive and available at most office supply stores) and revolving carousel put tools at my fingertips. I keep my pencils in holders that I make myself by gluing cardboard tube sections to pieces of foamcore board. My corner area is light and bright, and I like the view out the window.

Pencil Sharpener

Whether you love hand cranking or would much rather just *buzz* your pencil in and out of an electric sharpener, invest in a model with good blades that give you the point you want. Some sharpeners produce a shorter and more blunt point than others, so find out your preference before making a purchase.

Empty the sharpener frequently and keep the blades clean either by occasionally sharpening a hard lead graphite pencil or by brushing the blades with an old toothbrush.

Keep a small brush near your sharpener, or attach it right to your sharpener with a piece of tape. Drag your freshly sharpened pencil through the bristles to clean off any little pieces of wax or wood left by the blades.

Pencil Extenders

When the pencil gets short it's harder to hold and you lose leverage. Insert the stub into a pencil extender. Or you can glue the stub to the flat end of a new pencil of the same color. This allows you to continue to sharpen right through the stub and into the new pencil. Be sure to use strong glue or the stub may come off and get stuck in your sharpener.

Erasers

I prefer to use an electric eraser that fits in my hand. The advantage of using a *whirling* eraser is that it will remove most applied color (including burnished-on color). The friction created by rubbing back and forth over colored pencil with a regular eraser creates a smeary-looking stain called *slurry*, which soaks into the paper fibers and is impossible to remove. The battery-powered eraser doesn't produce slurry.

Color Lifters

Sometimes you need to remove some color without totally erasing the area. Use a kneaded eraser or a piece of mounting putty. Both warm to the hand and are pliable. But don't rub back and forth with them. Press the lifter against the area you want to lighten then pull it away at a right angle to the drawing surface. Mounting putty is more aggressive than a kneaded eraser and *pops* as you pull it away.

Erasing Shield

For exact and precise erasing it's nice to have an erasing shield. Made of thin flexible metal with a series of holes of different shapes and sizes, it lets you erase just what you want and no more.

PROTECT YOUR DRAWING

To protect your drawing from the moisture and oils of your hand, try using a **plastic notebook cover** as a hand rest. It's durable and easy to wash.

As you work, little bits of color or wood shavings are bound to fall on your drawing surface. Use a **soft clean brush** to remove them.

Heavy burnishing produces a grayish-white film called *wax bloom* that gradually appears on the surface of the applied color. When your drawing is finished, wipe any wax bloom carefully away with a tissue, and spray with a **workable matte fixative**. Not only does this seal and protect your work, it makes it possible for you to add more color by making the sprayed area tacky.

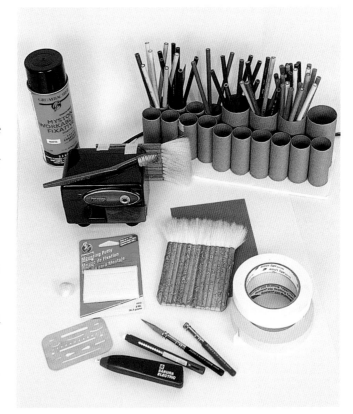

Minimal Tools and Equipment
From left to right, top to bottom: workable fixative (matte), pencil holder, toothbrush, electric sharpener with dustbrush attached, mounting putty, dust brush, plastic notebook cover (hand rest), white artist's tape (acid free), drafting tape (low tack), erasing sheild, battery-powered eraser, click eraser, pencil extenders

Application

Applying Pressure

The way you hold your pencil, the direction of your stroke, and the amount of pressure you use to make a mark can make a great deal of difference in how your finished painting will look.

If you grip the pencil tightly, you are probably going to make a darker mark than if you hold the pencil gingerly.

If you press the pencil firmly to the surface as you make a mark, the color will appear darker and more concentrated than if you used light pressure. Colored pencil artists vary the pressure of the pencil for two reasons:

Amount of Coverage

Lighter pressure means less complete coverage and that lets the texture (tooth) and color of the paper show through the painting. Heavier pressure means more complete coverage with little or no tooth or paper color showing.

Change in Value

Lighter application of the pencil results in a lighter value of the pencil color. A heavy application looks darker (lower in value) but can never be any darker than the pencil color itself.

Adjusting Values

Besides changing pressure to change values, you can also utilize the color of the paper to change your values. On a white surface the color lightens; on a black surface the color darkens. On a colored ground, the paper color adds its tint to the pencil color.

You may also choose to mix white, black or the grays (the achromatics) with your color to adjust its value, but this can dull or bleed out your color. So, rather than mixing the achromatics with a color, try mixing *other colors* with it. For example, use Indigo Blue and Dark Umber as an underlayer to establish values and make a unifying color base for the local color mix, thus augmenting and enriching any added color.

Pencil Point

Sharpen your pencil often. A blunt pencil point has trouble getting down into the valleys (crevices) of the paper, so for more complete coverage always work with a nice sharp point. I like to think of sharpening as "refreshing the point." A sharp point allows you to apply color down into the tooth and makes for much smoother-looking coverage.

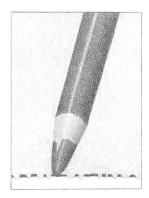
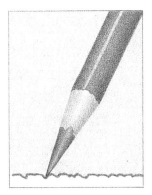

Changes in Value
On the left, value changes are made by changing pencil pressure using just one pencil (Peacock Blue). It becomes even easier to change value if you can find different values from the same or nearly the same color family. Then you only have to vary pressure where one color blends into another. On the right, Peacock Blue changes to Aquamarine and then to Light Aqua.

Keep Points Sharp
A dull point (left) deposits wax/color only on the hills (raised areas) of the paper. A sharp point (right) allows you to color down into the valleys (crevices) of the paper and keep application much smoother.

Strokes

The mark you make with your pencil is called a stroke. You can work in a linear manner so that each stroke is separate and stands apart from the strokes around it. Or you can shorten your stroke to apply just dots of color, but that takes quite a bit of time. You can also make strokes with the intention of filling in an area with smooth color, or with color that gradually lightens or darkens.

Smooth Application
Colorless Blender

As you apply the pencil to the paper, it puts down a layer of colored wax. If the paper is rough (toothy) it will have distinctive hills and valleys; the pencil will tend to hit the tops of the hills, and won't fit down into the valleys. Even smooth paper has a tooth and, for more complete coverage, requires care and patience to work the pencil down into it. Using a Colorless Blender as the last step smoothes the color.

Burnishing

Burnishing is an application of the pencil using very heavy pressure with the intent to totally fill the paper's tooth with color. Burnished color is very vibrant and saturated and appears darker than layered color. No paper texture is evident at all; the surface is totally covered and sealed with a heavy layer of wax. Burnished areas look like enamel paint and exhibit their own fascination and appeal.

Overlap Stroke **Circular Stroke**

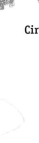

Squiggle Stroke

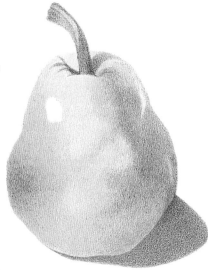

Layered Color
Value and color are developed by careful and even changes in pencil pressure. Colors are layered over one another to build color. Paper color shows through the pencil color as tiny white specks.

Colorless Blender on Top of Layers
The Colorless Blender is applied to already layered color in order to blend and spread it, and fill the paper's tooth. The texture of the paper is still apparent but the white specks are now filled in with color.

Technique

Blending Colors

When blending one color into another, work gradually and smoothly as you mix more and more of one color into the other. A little patience is all you need to make a smooth and gradual blend.

Linear Building

If you don't want to blend color gradually, you can use a technique that is more exciting to the eye. You can build color and value with lines rather than with areas of color. Keep your pencil sharp and don't do any blending at all. Overlap lines and where you want color to be more intense, keep the lines closer together or add the color's complement (its opposite on the color wheel).

Smooth Color Transition
Begin with one color and lighten pencil pressure gradually and smoothly toward the second color. Then take the second color and work it back into the first one in just the same way, so that when you are finished you can't tell where one color stops and the other begins.

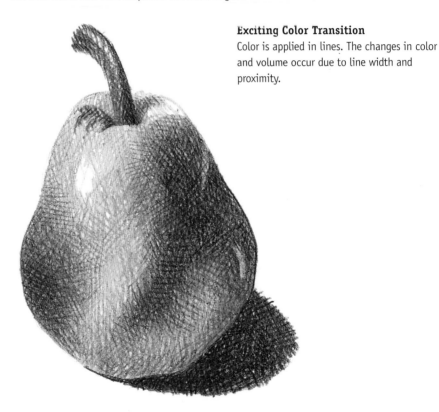

Exciting Color Transition
Color is applied in lines. The changes in color and volume occur due to line width and proximity.

Mixing Colors

Colored pencil, because it is a dry medium, has to be mixed by layering one color over another on the surface of the piece of art. The wonder and delight of the colored pencil lie in the beautiful color combinations you can make with layering. Since the wax is semitransparent, you can see down through one layer into another, and another, and so on. The color combinations are endless and the mixtures exquisite.

As with most mediums, the darker pencil colors are stronger and will tend to cover the lighter colors. Also, some colors are more opaque (less transparent) than others. They, too, cover better.

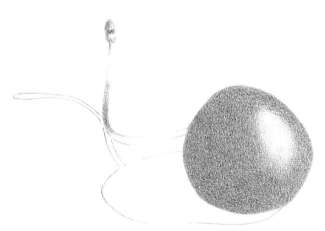

Establish the Color Base With Mahogany Red

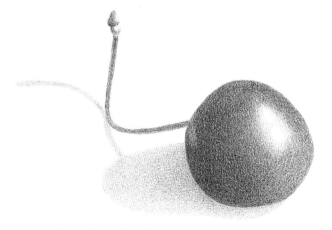

Develop Volume With Black Cherry

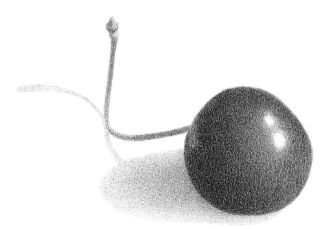

Complete the Local Color With Crimson Red and Scarlet Lake

Burnish

ME AND MY SHADOW | Janie Gildow, CPSA | 2" x 4" (5cm x 10cm) | Colored pencil on 140-lb. (300gsm) hot-pressed watercolor paper | Collection of the artist

More Techniques

Grisaille (pronounced *greese-eye***)**
Color added to value can sometimes be confusing, so many artists like to establish all of the values before applying any color. It's a much easier method to use if you have trouble interpreting color value.

Reverse Grisaille
When you work on a dark ground rather than a light one, you have to think in reverse as you develop the values. Instead of using pencils that are darker than the ground, you must use pencils that are lighter. Since the colored pencil is semi-transparent, most colors will look darker when applied to a dark ground. Where you want color to be dark, just apply it directly to the dark ground, but in order to make color light and bright, you'll need to first apply either white or one of the light opaque colors under it.

Grisaille
This tonal drawing, created with French Greys, is now ready for color. The values are all established and the layers that make up the local color mix should be applied right over the grays.

Reverse Grisaille
The lighter values are established with white or opaque light colors. Any colors applied over the light foundation will be lighter than colors applied directly to the black ground. Coloring in the background around the cast shadow allows the shadow to keep its darkness.

Impressed Line

Impressing a line into the surface of the paper or board makes it possible to stroke a pencil over the indentation to produce a fine line that is the color of the surface and not the color of the pencil. Leaf veins, cat whiskers and fine lace details are perfect for this technique. To impress lines, place a piece of tracing vellum over your drawing. Use a soft lead pencil to draw fine lines exactly where you want them. Then press down harder to impress the lines into the paper but don't break through the vellum.

Impressed Lines on White Paper

Impressed Lines on Applied Color

Impressed Lines on Colored Paper

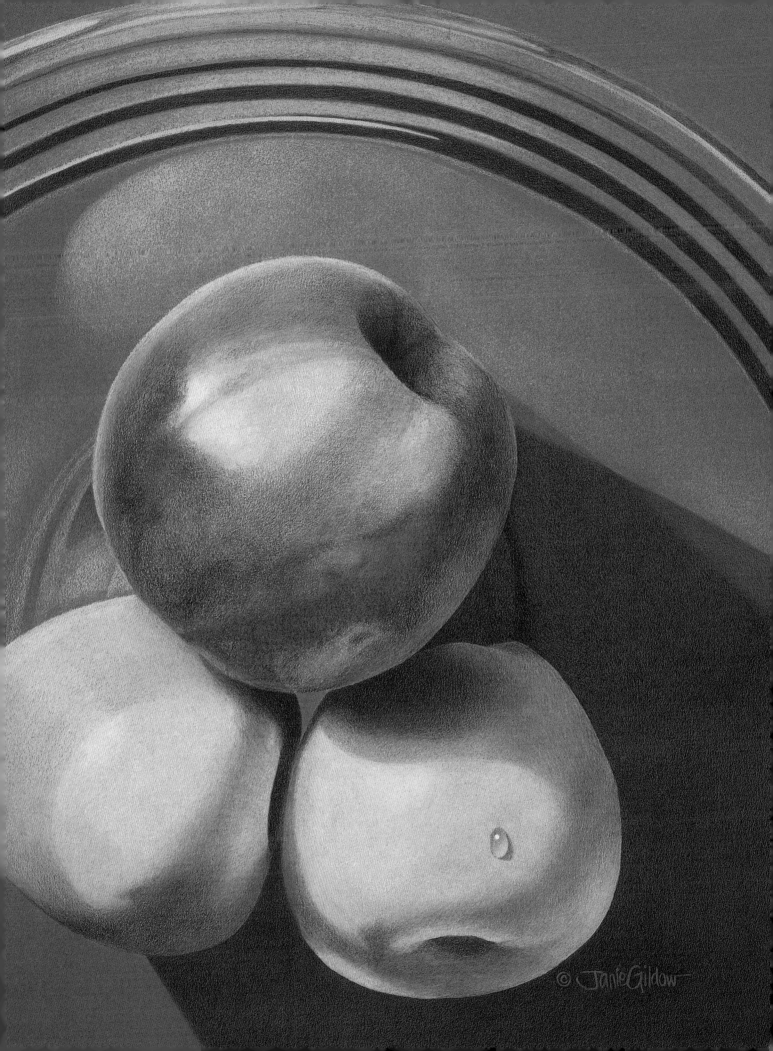

Pastels and colored pencil seem to have been made for each other—and for the artist who wants to work more quickly. Both mediums are dry and color is mixed on the surface of the painting. Each has a luminous quality of its own and the layering together of the two just intensifies the luminosity.

This chapter shows you how to combine colored pencil with pastels. Learn about pastels and what you can expect from them. Get a look at the tools and equipment you'll need. Learn how to control them and make them work for you. Then pick up your colored pencils. Apply them right over the pastel. Develop exciting new color combinations. Use your pencils to refine and smooth the pastel. Enjoy the control. Add those details. Experience the rich, sumptuous color. Start pushing your limits. Experiment! That's what this book is all about.

CHAPTER TWO

Colored Pencil
AND PASTEL

RONDELLE | Janie Gildow, CPSA | 14" x 10" (36cm x 25cm) | Colored pencil and pastel on Crescent regular mat board | Collection of the artist

Understanding Pastels

Pastels are color sticks that consist of finely ground pigment and gum. They are applied to a dry toothy surface by layering one color over another. Their color is deposited as powder that rests on, and fills in, the tooth of the surface. Pastels do not adhere well to a slick or smooth surface. The sticks can be used on end or can be laid on their sides for wider application.

Soft Pastels

Soft pastels are available in a large palette of colors. Within each color family there are several graded values of that one color. This feature is one of the definite advantages to using soft pastels. Soft pastels break and crush easily and it's difficult to get them to hold any kind of a point. By stroking them over sandpaper you can shape a point or develop an edge.

Hard Pastels

Hard pastels have a limited color palette, usually just one to three hues in each color family. Hard pastels hold an edge or point well, can be sharpened with an art blade or razor, and they don't color your fingers like soft pastels do. They lend themselves well to more linear applications of color and tend to rest on the top of the paper tooth rather than filling the valleys.

Pastel Pencils

A soft pastel in the form of a thin rod that is enclosed in a wood casing can be sharpened like a pencil. It holds a point and is excellent for detailed work or linear application but unsuitable for filling in large areas. The color palette is quite extensive. Your hands stay clean and the pencils don't deposit color on each other.

Oil Pastels

In these sticks of color, the binder is oil. Their application looks and feels like oil paint. Dry mediums like colored pencil or soft and hard pastels will not mix with or adhere to oil pastels. They are mentioned here only because they are considered part of the pastel family.

Art Stix

Art Stix are rectangular sticks of colored pencil "lead." Their hardness/softness falls somewhere between hard pastels and soft pastels. They are cleaner to work with because they are waxy rather than dusty or powdery. These sticks can be sharpened and pointed on sandpaper and dissolved with solvents like Turpenoid or ordinary mineral spirits, but not with water.

Tools and Equipment

Surfaces

Sanded papers and boards have been created with a sandpaper finish on one side. These papers and boards are excellent for pastel and the drier mediums, and for a looser approach. Color adheres well to them and can be applied in many layers. The roughness of the finish does tend to eat pencils at a rather alarming rate.

Pastel granulated acrylic primer (a liquid available in colors) can be applied to nearly any surface, making it conducive to pastel or pencil.

Clay-coated papers and boards can be purchased in either a smooth or a textured finish. They accept wet and dry media very well. Some are coated with black (like scratchboard) for sgraffito (see page 82 for more information on the sgraffito technique), giving them even greater versatility.

Blenders

Tortillions (pronounced *tor-tee-yong*), or paper stumps, are available in several lengths, shapes and sizes. Hold them as you would a pencil and sharpen them in your pencil sharpener if they fit into the opening. You can clean and reshape them by rubbing the tip across a piece of fine sandpaper. They can pick up and transfer color, so be sure you check the tip before stroking it across an area of a different color.

Brushes work very well as blenders. The bristles hold color, so be careful not to transfer unwanted color with a loaded brush. Wash your brushes at the end of your pastel-painting session so that they will be dry for the next. Don't use a wet or damp brush to blend pastel color.

Tissues are great for blending large areas. Their softness and pliability make for smooth blending. Wrapping one around your finger keeps your finger clean, too.

Fingers are indispensable. Sometimes they may seem just a little too big for those small places, but they are excellent for blending, and you've got ten of them. I always end up with a different color on each one.

Color Lifters

Soft white erasers pick up color, but they can also smear it around if it's applied too heavily. Use them gingerly. The white click erasers are good for cleaning up small areas, but they too can smear and spread color.

Kneaded erasers absorb a *lot* of color before they become saturated. They are excellent for lifting off unwanted color. Their really great advantage is that they are very pliable and you can shape them to fit exactly the area you want to lift.

Mounting putty works just like the kneaded eraser but is more aggressive in its lifting power. After lifting color, be sure to pull, fold and stretch the pliable lifters so that they absorb the color and *clean* themselves.

Battery-powered erasers take it all off. The tiny soft eraser tip removes color exceptionally well as it revolves. Clean and reshape it by touching the spinning tip to a piece of clean paper.

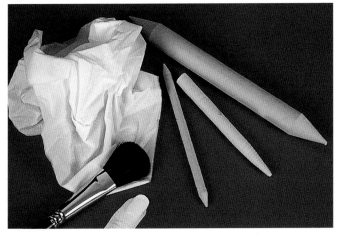

Blenders
You can blend your pastel colors on the page with tortillions, brushes, tissue or even your own fingers.

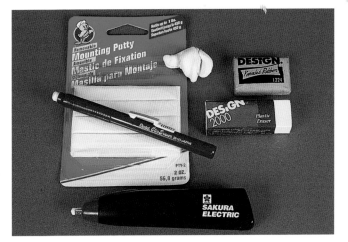

Color Lifting
Lift out pastel with soft white erasers, kneaded erasers, mounting putty or battery-powered erasers.

Sharpeners

Sandpaper blocks are used for sharpening pastel sticks to a point and for reshaping and cleaning tortillions. When the top piece of sandpaper is full of color, tear it off, throw it away and use the new clean piece underneath.

Use an **art knife** to *point* a pastel stick, but be careful: sticks are prone to crumble when shaped in this manner. The art knife can also be used as a color lifter and fine-line maker. Scratch through the layer of pastel with feathery strokes to reveal the color of the paper beneath.

Fixers

Workable fixative allows you to easily lift or erase color that has been applied under the fixative. **Permanent fixative** completely seals in color. The advantage to using permanent fixative is that you can rest your hand on a fixed area and not lift or smear the color. And you can apply more color over it without pulling any of the underneath color up into the new color. The disadvantage is that you'd

better be very sure that color is applied exactly as you want it, and exactly where you want it, before you spray. Once the color is fixed, you can't erase it or lift it.

You can fix color with an aerosol matte spray fixative. Be sure to work in a well-ventilated area or outdoors. Test the spray on a piece of scrap paper first. Then place your work on a piece of scrap paper 10 to 12 inches (25cm to 30cm) larger than the work on all four sides. Spray your work in a vertical position. That way, any larger drops of fixative fall to the floor leaving just the finer mist to reach the painting.

Hold the can 1 to 3 feet (31cm to 92cm) from your work. Direct the spray toward the outside of the painting (onto the scrap paper) and then spray back and forth, each time going beyond the painting and out into the scrap paper. Overlap the strokes for even coverage. Several light coats are better than one heavy one. Let each coat dry before applying the next.

If your work was done on absorbent paper, you can opt to spray the back of

the work instead of the front. The fixative soaks through the paper and attaches the pastel to it from the back.

Cleanup

You can't beat disposable wipes for cleanup. They pull out one by one, they are already dampened, and they clean up pastel dust from your drawing table and from your fingers like crazy.

FIXATIVE CAN CHANGE YOUR COLORS

It's important to remember that fixative can have an effect on colored pencil, and that each colored pencil brand reacts differently to fixative. For example, if you work on a dark surface then spray your work with fixative, the colored pencil applied under the fixative may fade or darken. Also, oil-based colored pencils applied over fixative don't bond to it, and will just brush off your painting.

Sharpeners
Use a sandpaper block or an art knife to sharpen pastels.

Fixative
Use permanent or workable fixative to seal in your pastel color and avoid excessive smearing.

Cleanup
Disposable wipes are useful for cleaning up pastel dust.

Mixing Colors

Color mixing is done on the surface of the painting. Application takes place as strokes of color that are either left as individual strokes or blended and smoothed with fingers, cloth or tissue, brush, blending stumps or tortillions.

Remember that you can layer and blend related colors (those near one another on the color wheel) more easily, and with much more predictable results than if you mix contrasting colors (those opposite or nearly opposite). Those mixtures tend to quickly turn into brown or gray because the opposites (complements) neutralize each other.

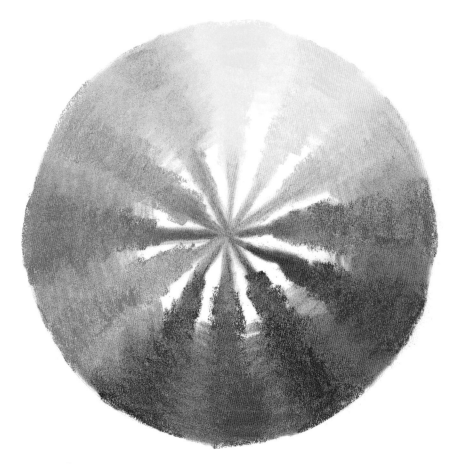

Mixing Colors
Mixing colors across the color wheel quickly neutralizes both. Colors next to or near each other mix with more predictable results.

Learning Basic Coverage

Achieving complete and even coverage with the colored pencil is a timely process. A layer of pastel color on the paper's surface saves time and quickly provides a tinted base for the pencil. You can use graded color to develop volume with the pastel, or you can just apply the pastel as a flat color and use the pencil to develop changes in contour.

The pastel is applied first and sprayed with fixative so that the consequent layers of pencil will adhere to it. The waxiness of the pencil discourages the pastel from sticking to it so it works best when it is applied last.

Remember that the pastel color, rather than the color of the paper, will show through the applied pencil as little dots of color.

Let the Pencil Do the Work
Lay down a flat color (just one value) with the pastel (left) then develop color and value changes with the pencil (right). The flat color affects the overlying semitransparent pencil and it shows through the pencil as tiny dots. This method is considerably slower than the method shown below.

Let the Pastel Do the Work
Develop volume (by changes in color and value) with the pastel (left). Then add the colored pencil (right). You won't need to spend as much time applying the pencil since the color/value changes are already made.

Pastel Creates Subtle Color Changes

Diagonal shadows and bright contrast lead to the center of interest in this gentle statement of youth and discovery. Splashes of yellow dot the landscape, adding their warmth to the composition. Colored pencil combined with pastel creates the soft and subtle changes in color.

NATURAL BEAUTY | Connie Andrews | 20" x 16" (51cm x 41cm) | Colored pencil and pastel on Crescent no. 1039 Auburn regular mat board | Collection of Beryl G. and Lawrence C. Baker, Jr.

Pastel Can Be Brilliant and Rich in Color

Nupastels and Prismacolor pencils produce the brilliant, jewel-like color in this whimsical piece. Shelley applied several layers of color alternately with a combination of blending stumps and chamois to smooth and burnish each layer to high gloss, achieving this lustrous paintlike quality. To keep her work clean and smudge free, she wears a cotton glove with the thumb, index and middle finger cut off while she works.

THE COUNSELOR | Shelley Robinson | 14" x 13" 36cm x 33cm) | Colored pencil and pastel on black Crescent Magic black core mat board | Collection of the artist

Demonstration | **Pastel**

REALISTIC STILL LIFE | Janie Gildow, CPSA

In this exercise, you'll work quickly by establishing a pastel color base for the pencil. Utilize your pastels to let them do a lot of the work for you. They'll quickly fill the paper tooth with their own color, giving you a foundation of color quite different from, and unaffected by, the black of the surface. The pastels will approximate the color and value changes that you'll later sharpen and enhance with the pencil.

Surface
Black LetraMax board

Soft Pastels
Dark blue, dark red-violet, medium gray, orange, pale orange, pale yellow, white

Prismacolor Colored Pencils
Blue Violet Lake, Carmine Red, Cool Grey 50%, Cool Grey 70%, Copenhagen Blue, Cream, Deco Orange, French Grey 50%, Henna, Mineral Orange, Pale Vermilion, Spanish Orange, Sunburst Yellow, Terra Cotta, Tuscan Red, Ultramarine, White

Other
Battery-powered eraser, matte-finish spray fixative, mounting putty or kneaded eraser

1 | **Establish the Base for the Background**
Draw in your subject (see page 132) using French Grey 50% pencil. Apply pastel colors, starting with medium gray on the inside, then dark red-violet, and going into dark blue on the outside edge. Stroke the color on, then blend with finger or tissue. These colors blended together will complement the warm yellow apricots and provide a softer value behind the ribbon.

2 | **Establish the Apricots' Foundation**
Begin to shape the apricots by giving them volume. The areas toward the light source are higher in value, the color/shadow gradually darkening toward the side away from the light. Apply pastel colors in order listed, using pale yellow on the top half of each apricot, pale orange on the middle sections, orange on the lower and middle sections and white in the highlights. Blend with finger or tortillion. Reapply color if necessary.

3 | Refine the Background and Subject

Pastel dust will begin to leave some residue on the black surface, so you will need to clean up edges and restore the black. Use a battery-powered eraser to sharpen the outlines of the ribbon and apricots and use a piece of mounting putty or kneaded eraser to lift dust and chips.

Then, in a well-ventilated area, lightly spray the surface of the drawing with fixative. Pastel will darken with the application of fixative, so if you need to add more pastel for color, add it over the dried fixative and respray. Use colored pencils to fill in and enhance the pastel colors. Even the background by combining Henna, Cool Grey 50% and Cool Grey 70% colored pencils and blending over the pastel.

Apply colored pencil over the apricots in this order: Cream on the top, Deco Orange in the upper middle, Mineral Orange in the lower middle, and Terra Cotta on the shadowy areas. These colors augment and enrich the pastel colors you have already applied and continue to establish the form and volume of the apricots.

Apply Ultramarine as the ribbons' local or most characteristic color, using White for the highlighted areas.

4 | Complete the Composition

Apply Deco Orange lightly to the background. Start on the left and gradually reduce pressure toward the center. The Deco Orange complements the blues in the background and in the ribbon and, when layered over the blended gray and red-violet combination, lends a quiet glow to the background behind the apricots and ribbon.

Now warm the apricots with colors containing red and yellow. Notice how the shadows on the apricots are loaded with color.

Refine and smooth the topmost apricot, going from Pale Vermilion to Carmine Red to Tuscan Red in the shadows, and using Spanish Orange and Sunburst Yellow in the middle section.

Refine the bottommost apricot with Pale Vermilion and Mineral Orange in the shadow area, and Spanish Orange and Sunburst Yellow in the middle section.

Use these same colors to refine and smooth the remaining apricot, paying attention to light and shadow areas.

Blend the ribbons with Blue Violet Lake closer to the highlights and Copenhagen Blue in the darker areas. The Copenhagen Blue enriches the local color of the ribbon; the Blue Violet Lake makes the transition from the darker blue to the light highlight.

SHADOWPLAY | Janie Gildow, CPSA | 6" x 8"
(15cm x 20cm) | Colored pencil and pastel on black
LetraMax board | Collection of the artist

WHAT TO DO WITH ALL THAT DUST?

The best way to get rid of excess pastel dust is to quickly turn the work upside down over a large sheet of newspaper or other scrap paper. Lightly tap the back and the powder will fall onto the scrap paper; then roll up the scrap paper and throw it away. If you tilt your work sideways, gravity will take over and the excess powder will resemble a waterfall of color, right over areas you don't want affected.

Demonstration | **Pastel**

LOOSE LANDSCAPE | Janie Gildow, CPSA

If you want to emphasize and take advantage of the pastel application techniques, you can work more loosely, then enhance the work with colored pencil, keeping the exciting strokes of the pastel evident in the finished piece.

Surface
140-lb. (300gsm) hot-pressed watercolor paper

Pastel Pencils
Dark grass green, dark pine green, gold ochre, indigo, light cloud blue, light warm gray, medium grass green, medium warm brown, olive green, pine green, terra cotta, yellow-green

Prismacolor Colored Pencils
Rosy Beige, Apple Green, Blue Violet Lake, Celadon Green, Chartreuse, Cloud Blue, Dark Brown, Goldenrod, Indigo Blue, Limepeel, Marine Green, Periwinkle, Sienna Brown, Slate Grey

Other
Art knife, graphite pencil, matte workable fixative

1 | Lay in the Groundwork With Pastel Pencil
Use a pencil to loosely map out the basic shapes of your landscape. Apply light cloud blue to the sky using vertical strokes. Apply light warm gray lightly in the same manner over the sky to indicate an overcast day.

Use dark pine green in vertical strokes for the distant mountain. Use dark pine green and indigo crosshatching in the near mountain.

Use dark pine green and indigo vertical strokes to make a dark mass of trees by the near mountain. Pine green and indigo are cool colors, which encourage the mountains and trees to recede and tuck themselves into the background.

Apply light cloud blue and light warm gray in horizontal strokes on the dark edge of the river. Toward the middle of the river, apply light cloud blue with short strokes going in many different directions (scumble) to indicate the surface and current in the water, then move into vertical strokes on the right side. Spray all with workable fixative.

2 | Continue to Build Color With Pastel Pencil
Warm the shore with earth tones. Refine the water line with terra cotta. Apply medium warm brown and gold ochre to the left shoreline.

Add indigo to the darker parts of the water and along the waterline to indicate the reflections of the trees in the water.

Darken the mountains with indigo and pine green.

Darken the trees with indigo. On the lighter trees, use a combination of medium grass green, yellow green and olive green. The yellow in these three greens will coax the trees to jump forward and appear closer. Spray all with workable fixative.

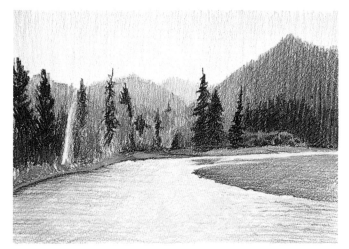

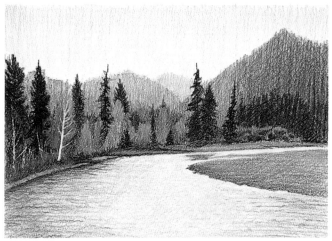

3 | Refine the Right Side With Colored Pencil

Apply Rosy Beige to the shoreline, the right shore and the mountains. This repetition of color will help unify the color in your composition.

Add Blue Violet Lake to the mountains by crosshatching. These separate strokes of color will begin to soften the color of the pastel, contributing to the impression of depth and distance, or aerial perspective.

Smooth the center of the river with Cloud Blue. Use Slate Grey and Periwinkle to define the water surface, indicating current and the reflected trees.

Even out the color of the sky with Blue Violet Lake and Cloud Blue.

Apply Marine Green to the water at the left shoreline reflections and to the leafy trees to warm them. Use Dark Brown to edge and define the right shoreline. Color the farthest part of the right shore with Cloud Blue and, to warm and bring the nearest part forward, apply Goldenrod.

Use Indigo Blue in the pines to darken and define them; Apple Green, Celadon Green and Limepeel in the lighter trees to build rich color.

4 | Complete the Left Side With Colored Pencil

Fill in and define the trees with Chartreuse, Celadon Green and Apple Green. Use these light colors to brighten and warm the leaves. Darken the pines even more with a heavier application of Indigo Blue. Use an art knife to scratch out the white trunks and branches of trees here and there.

Complete the shoreline with Sienna Brown and Goldenrod. Use the battery-powered eraser to lighten the shoreline and indicate the riverbank.

Complete the water with Slate Grey and Periwinkle. Both colors add blue to boost the color of the water.

Separate strokes of both pastel and colored pencil should be evident in your finished landscape. The color palette indicates a gray and overcast day.

HOMONYM | Janie Gildow, CPSA | 6" x 8" (15cm x 20cm) | Colored pencil and pastel on 140-lb. (300gsm) hot-pressed watercolor paper | Collection of the artist

Get it wet! This chapter gets you acquainted with mediums that flow and drip. Learn all about watercolor, acrylic and ink—how they're alike, and how they're different. Each has its own unique set of characteristics.

Watercolor is transparent. Gouache is opaque. Neither of them is permanent. Colored ink is transparent. Acrylic can be just about any consistency, but both ink and acrylic, when dry, become permanent. See how well each medium (in its own way) works in combination with the colored pencil.

Which mediums will you choose: workable or permanent? Try them all, then decide. Follow along as experienced artists show you just how they manage these mediums and combine them with colored pencil. They'll give you helpful hints and they'll show you exactly how they get results. Start your cruise through the exciting world of wet stuff right now. Turn the page and take up the challenge!

CHAPTER THREE

Colored Pencil
AND WATERMEDIA

DISTORTION(S) | Janie Gildow, CPSA |
11" x 10" (28cm x 25cm) | Colored pencil and acrylic on Canson Mi-Teintes no. 431 Steel Gray paper | Collection of the artist

Brushes and Surfaces for Watermedia

Surfaces

The smoothest papers and boards are labeled **hot pressed**. They don't accept heavy colored pencil application and buildup because they exhibit very little tooth or texture. It's easy to create a smooth and even tone on them with the pencil by keeping your pencil points sharp and working the colors down into the tooth. These surfaces are excellent for sharp detailed realism.

Cold-pressed papers and boards are rougher and take more abuse. They exhibit a noticeable texture that accepts both dry and wet mediums very well. You can apply color heavily, and erase it without wearing through the paper.

Soft-pressed papers accept more pencil color than the hot-pressed and exhibit more tooth. They are not as rough as the cold-pressed papers.

Rough papers and boards accept wet and dry media well and stand up to heavy layering. Pencil application is grainier in appearance because it's difficult to work the color down into the tooth.

Specialty papers, such as rice paper, accept colored pencil and other mediums to greater or lesser degrees. Their bonus is the added dimension of their own unique properties.

Brushes

Natural Bristles

The very best (and most expensive) bristles are from the tail of the male kolinsky sable mink. Compared to the camel hair brush at the other end of the bristle scale, you can see why they are so expensive. *Camel hair* isn't really from camels, instead it's the general term for the most inexpensive bristles (pony, goat, ox or the leftovers from the floor).

Synthetic Bristles

Synthetic (or man-made) fibers are generally better for acrylic paints and are easy to clean. You can wash them in extremely hot water without harming them. If you wash a natural brush in very hot water, you will remove the natural oils that give it its flexibility. Synthetic fibers are *feathered* on the ends to hold more paint and then release it in a smooth flow. The fibers are flexible with a good snap (the bristles spring back to their original shape after making a stroke).

Some brushes are a mix of synthetic fibers and natural bristles, making them capable of holding more paint. Brushes made of synthetic bristles alone don't have the holding capacity that those with natural bristles do.

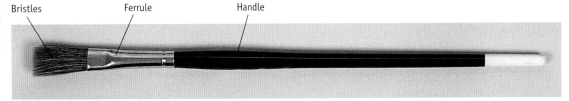

Bristles Ferrule Handle

Parts of the Brush

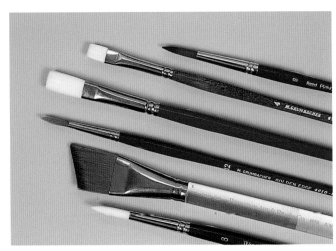

Synthetic Bristles

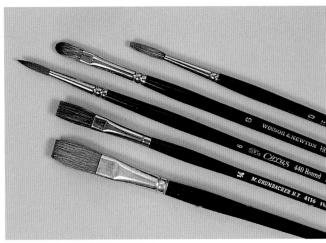

Natural Bristles

Understanding Watercolor

All paints consist of pigment (color particles) in some kind of liquid medium (carrier or binder) with a small percentage of other ingredients added to sharpen their attributes in one direction or another.

The binder or medium for all watercolor paints is gum arabic, a water-soluble substance. Because it is water based, watercolors are not permanent.

There are two kinds of watercolors: opaque and transparent. In both kinds, as the binder dries, it sets and fastens the pigment to the surface.

Opaque Watercolor

With this type of paint, colors cover one another and it's possible to go back into your work to reestablish the white areas after you apply color. Paint is applied more heavily and mixtures are thicker. Thinning the paint does not produce clear washes.

Professional grade opaque watercolor is called gouache (pronounced *gwash*) and is available in tubes. Like transparent watercolor, gouache is not permanent, but does adhere to the paper surface when dry. Student grade opaque watercolor is called tempera or poster paint.

Transparent Watercolor

Transparent watercolor is usually applied to white paper in washes of diluted color ranging from saturated hues to light tints. Each color can be seen through every other color due to the translucency of the paint. The white of the paper glows through the combined layers of transparent color with a magnificent effect that cannot be duplicated with any other medium. Color can be manipulated to some degree on the surface of the work.

Opaque

Transparent

Tools

Paints

Watercolor paints generally come in tubes or jars. Tube paint is moist and thick and can be thinned with water. Application is with a brush or similar applicator and color mixing is done on a palette. You can also use pans of paint. These cakes of color are dry and must be moistened with water. Application and color mixing are the same as for tube color.

Water-Soluble Pencils and Crayons

In water-soluble pencils, the paint is dry and in the form of lead encased in wood. This form gives you the most control. You can draw/color with the pencil then add water with a brush, spreading the paint and smoothing the dry strokes. It is also possible to wet the paper, and apply the color to the damp surface. You can lift color from the pencil point/tip with a wet brush and transfer the color to your painting surface too.

Watercolor crayons deposit nice juicy color. Use them the same way you use water-soluble pencils.

Resists

Resists, such as **masking fluid**, can be applied over areas of the paper that you want to keep white. You let the mask dry, and then remove it when you are finished.

You can also use **wax crayons** to isolate color or keep it from flowing where you don't want it. But the wax stays on the surface and can't be removed later.

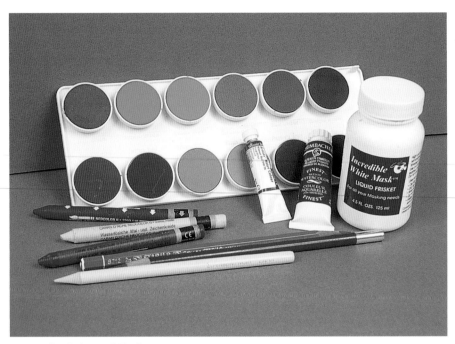

Watercolor Paint and Resists
Tubes, pans, pencils, crayons and masking fluid.

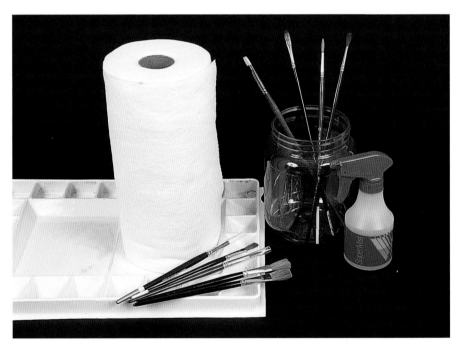

Watercolor Tools
Water container, brushes, mister, palette and paper towels.

Techniques

Due to its wet nature, watercolor paint can produce anything from a miraculous event to a happy accident to an unexpected and uncontrolled "eeeeeek!"

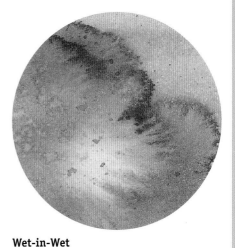

Direct Painting
When the paint is applied onto dry paper it gives you more control and harder edges.

Wet-in-Wet
Wet the paper, then apply the color to the damp surface. While the paper is still wet, add another color directly next to the first and watch the colors mix on their own right on the paper. Painting wet-in-wet gives soft edges.

Glazing
Apply color from your palette onto your dry paper one over the other, letting each color dry before adding the next. The white of the paper will show through and add its brilliance to create glowing color.

Special Effects
To further enhance your work, you can create interesting effects with dry brush, spattering, stencils, masking fluid, art knives or a battery-powered eraser.

Demonstration | **Watercolor**

GRANNY SMITH APPLE | Janie Gildow, CPSA

It's easy to make an apple that glows with color when you first underpaint with watercolor and then add colored pencil. The wash of watercolor fills in and tints the fibers of the paper. It also changes the tooth, giving hot-pressed papers and boards just that little bit of texture necessary for accepting multiple layers of colored pencil.

Not only does applying a layer of watercolor first speed up the coloring process by giving you the opportunity to color an entire area quickly, it lends richness to the colored pencil and adds a new depth of color not possible with either medium alone.

Surface
140-lb. (300gsm) hot-pressed watercolor paper

Brush
no. 4 round

Grumbacher Artists' Watercolor
Burnt Sienna, Cadmium Yellow Medium, Cobalt Blue, Cobalt Violet, Emerald Green

Prismacolor Colored Pencils
Apple Green, Burnt Ochre, Cloud Blue, Dark Green, Grass Green, Indigo Blue, Limepeel, Peacock Green, Tuscan Red, Yellow Chartreuse

Other
Battery-powered eraser, graphite pencil

1 | Lay a Watercolor Base

Draw your apple (see page 132) using light pencil lines. Tint the apple with an Emerald Green, Cadmium Yellow Medium, Burnt Sienna mix, keeping the color more concentrated on the shadowed side and thinning the mix with water as you approach the highlight. Let dry.

Mix Cobalt Blue, Cobalt Violet and Burnt Sienna for the shadow. Add a tiny amount of Cadmium Yellow Medium to warm and mellow this cool blue. Let dry.

Your application of watercolor doesn't have to be smooth and even. It's merely the base for the colored pencil. Later, when you layer the pencil over the area of dried watercolor, your brushstrokes won't show.

2 | Begin the Local Color With Colored Pencil

Make sure the painted areas are completely dry, then use Indigo Blue to contour the apple and create the illusion of depth. Be sure to color around the freckles. Let the local color show through them. Reduce pencil pressure toward the highlight, on the left edge of the apple, and on the bottom near the shadow. Then apply Dark Green over the Indigo Blue in exactly the same manner.

Use Indigo Blue to establish the shadow on the left side of the stem. The cast shadow is darkest immediately under the apple and gradually lightens upward. Use Indigo Blue to even the application of watercolor and fill in color. Reduce pressure toward the upper part of the shadow to lighten it just a little.

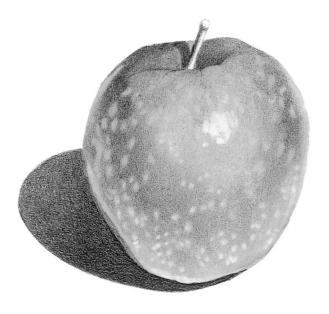

3 | Deepen the Values

Apply Peacock Green over the mix of Indigo Blue and Dark Green on the apple and extend the coverage closer to the white highlight and out toward the edge of the apple. Lightly apply Grass Green around the white highlight. Reduce pressure even more toward the darker areas to gradually blend it into the already applied color. Soften the contrast of the freckles on the top half of the apple by coloring lightly over them with Apple Green. Use the battery-powered eraser to lift color and lighten the spots on the bottom half of the apple.

Apply a mix of Grass Green and Apple Green immediately under the apple as reflected color in the shadow. Add a light layer of Tuscan Red to warm the center portion of the shadow and emphasize the bottom edge of the apple.

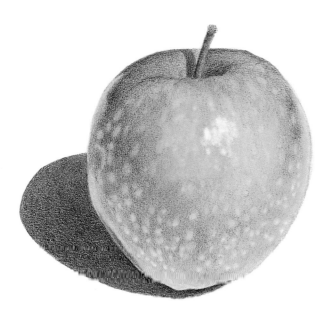

4 | Make the Color Pop

In the lightest areas of the apple (around the highlight and at the bottom), layer a combination of Limepeel and Yellow Chartreuse. Use Tuscan Red to punch up the color at the top edge of the apple, the shadow cast by the stem, and the valley around the stem. This dark red adds a soft complement to the green.

Apply Burnt Ochre over the entire stem to complete its local color.

Use Cloud Blue on the lightest part of the shadow and reduce pressure toward the darker area to gradually blend and smooth the mix.

GOOD ENOUGH TO EAT | Janie Gildow, CPSA | 3" x 4" (8cm x 10cm) | Colored pencil and watercolor on 140-lb. (300gsm) hot pressed watercolor paper | Collection of the artist

Demonstration | **Watercolor**

CHERRIES | Barbara Benedetti Newton, CPSA

Colored Pencil and Watermedia

Watercolor can serve as a foundation for colored pencil and at the same time retain some of its own distinctive character. In this exercise, you'll learn how to apply watercolor to produce a softly textured background and a color base for your subject. You'll lighten some areas by lifting color, then complete the painting with colored pencil to soften the background and intensify the subject.

Surface
140-lb. (300gsm) hot-pressed watercolor paper

Winsor & Newton Watercolor
Cadmium Red, Cadmium Yellow, French Ultramarine Blue

Brushes
no. 2, no. 8 rounds

Prismacolor Colored Pencils
Slate Grey, Violet, White, Indigo Blue

Polychromos Colored Pencils
Burnt Carmine, Dark Flesh, Light Carmine, Light Ochre

Other
Battery-powered eraser, graphite pencil, paper towels, plant mister

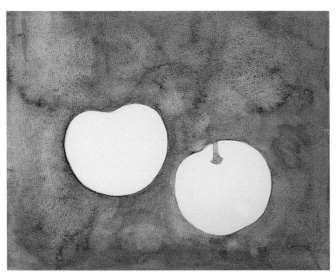

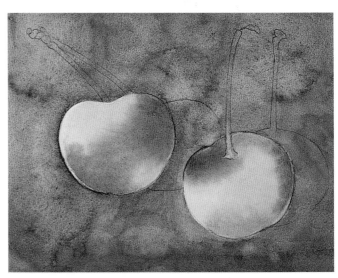

1 Protect the Subject, Begin the Background
Sketch in your cherries and cast shadows (see page 132). Apply a line of white wax or oil based colored pencil just inside the graphite line of the cherry body as a resist to prevent the background color from flowing into the cherry.

Mix equal amounts of Cadmium Yellow and French Ultramarine Blue watercolor with water. Load the no. 8 round brush with the mixed color and apply it to the background area. Don't worry about keeping the color even. Modulated or juxtaposed color (color next to color instead of one color layered on the other) is your goal. Work carefully around the cherry bodies, but paint right over the stems and the cast shadows.

2 Finish the Background, Start the Subject
While the background area is still wet, drop water into the applied color to create interesting patterns and changing values. Let it dry completely.

When the background is dry, use a battery-powered eraser to erase the line of white wax colored pencil around the perimeter of each cherry. Wet the cherries with clear water. Work quickly while the cherries are still wet and drop Cadmium Yellow onto the wet surface of the cherry. Do the same with Cadmium Red. Let the colors flow together while retaining some distinctive areas of red and yellow.

Leave some of the edge of each cherry uncolored, or go back once the cherries are dry and use a battery-powered eraser to lift color. A halo of white will help the cherries look three-dimensional.

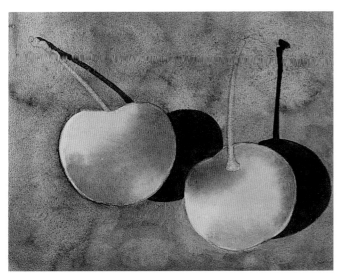

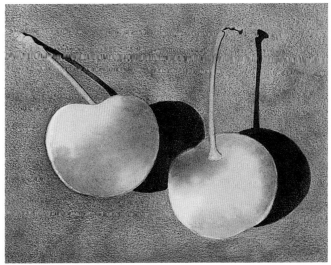

3 | Build the Light and Shadow

Use the no. 2 brush and clear water to repeatedly stroke, or lightly scrub the background color from the stems until the white of the paper shows. Rinse the brush frequently with clean water so that you are constantly removing color. Blot the brush on a paper towel and touch it to the stems to soak up any excess water. Allow to dry completely.

Mix Cadmium Red and French Ultramarine Blue watercolor together and paint the cast shadows. Apply as many glazes as necessary to obtain a dark, rich color. Work carefully around the edges of the cherries. Let each layer of glaze dry before applying the next.

4 | Soften the Background

Apply Slate Grey and Violet colored pencils lightly to the background in a juxtaposed manner to subdue the effects of the watercolor in the background. The juxtaposed colors add texture and interest.

Layer first Indigo Blue and then Violet colored pencils over the cast shadows to darken them and sharpen their edges.

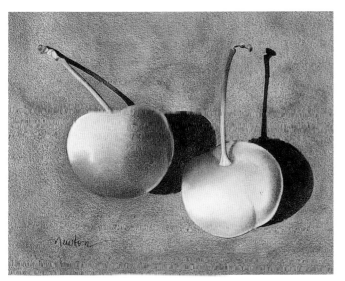

5 | Punch Up the Cherries

Use Burnt Carmine and Indigo Blue to lay in the detail and darker parts of the stems. Enrich with Dark Flesh.

Layer Light Ochre over the yellow areas of the cherries, blending it lightly into the red. Bounce some Light Ochre into the bottom right of the left cherry as reflected color. Add a little to the stems.

Layer Light Carmine over the red areas to enrich their color. Add it to the tips of each stem and to the upper half of the stem on the right.

Apply Dark Flesh to the center of the cherry on the left and to the top and bottom of the cherry on the right. Use it to blend the areas where red meets yellow.

Deepen the reddest areas with Burnt Carmine and add Burnt Carmine to the stem of the cherry on the right. Brighten the highlights with White.

TWO CHERRIES | Barbara Benedetti Newton, CPSA |
6" x 7" (15cm x 18cm) | Colored pencil and watercolor
on 140-lb. (300gsm) hot-pressed watercolor paper |
Collection of the artist

Demonstration | **Water-Soluble Colored Pencil**

LILY | Kristy A. Kutch, CPSA

Water-soluble colored pencils are a natural for making easy and colorful backgrounds. When they are used in combination with an old toothbrush and masking film, they become the poor man's airbrush, providing airbrush-like effects with none of the expense.

In this exercise, first you'll complete a lily; then use masking film to protect it while you spatter pigment to create a rich, yet simple background.

Surface
115-lb. (240gsm) hot-pressed watercolor paper

Polychromos Colored Pencils
Apple Green, Canary Yellow, Chrome Yellow Light, Cream, Golden Ochre, Grey Green, Lilac

Prismacolor Colored Pencils
Black Grape, Limepeel, Tuscan Red

Prismacolor Verithin Colored Pencils
Gold Ochre, Lavender, Tuscan Red, Vermilion

Faber-Castell Albrecht Dürer Water-Soluble Colored Pencils
Canary Yellow, Mauve, Wine Red

Other
9H graphite pencil, Colorless Blender marker, Colorless Blender pencil, HB graphite pencil, heavy tracing vellum, masking film, old toothbrush, Sanford Sharpie Ultra Fine Point permanent marker, scissors, tissues, ultraviolet light resistant spray

1 **Begin the Values**
Lightly sketch the lily with the HB pencil (see page 133). Apply Cream to the lightest parts of the petals, leaves and buds. The Cream serves as a unifying foundation for the succeeding layers of color.

Begin to develop the darker areas by first layering Golden Ochre and then Violet Light on the darkest parts of the petals, along the creases and down into the throat of the flower. To blend and soften the color on the petals, apply Canary Yellow over the layered Golden Ochre and Violet Light, continuing it out into the Cream.

Use the same colors to suggest the darker values on the buds, leaves and stems then add Apple Green and over it apply Grey Green to further darken those values.

2 **Impress the Vein Lines and Build Color**
Impress the lines with a 9H pencil to indicate the veins in the leaves, stems and buds. (See page 23 for instruction on creating an impressed line.)

Use a blunt point to color across the impressed lines. Deepen the color on the leaves, stems and buds first with a layer of Apple Green and then with a layer of Tuscan Red thick lead pencil.

Apply another layer of Golden Ochre to the darker areas in the petals, followed by Chrome Yellow Light to enrich and deepen the yellow.

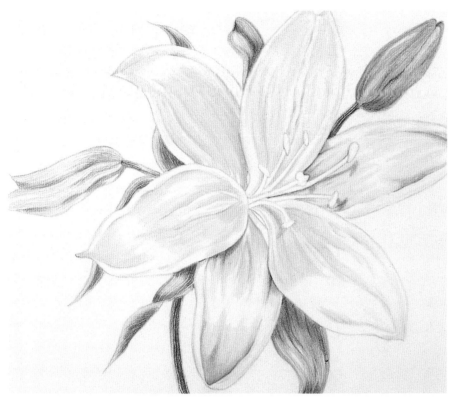

3 Punch Up Color

Using medium pressure layer Canary Yellow followed by Limepeel on the leaves, stems and buds. Burnish with the Colorless Blender pencil and then repeat with layers of Canary Yellow and Limepeel.

Burnish the flower with Cream. This smoothes the paper tooth and gives a shimmery effect to the entire lily. Reapply Golden Ochre and Chrome Yellow Light, and add a touch of Canary Yellow for warmth.

Use Black Grape to softly define the hollows on the edges of the petals where they curve upward and where the stamens cast their shadows. Add Black Grape and the thick lead Tuscan Red to the stems, leaves, and to the creases in the buds to continue to darken values and augment local color.

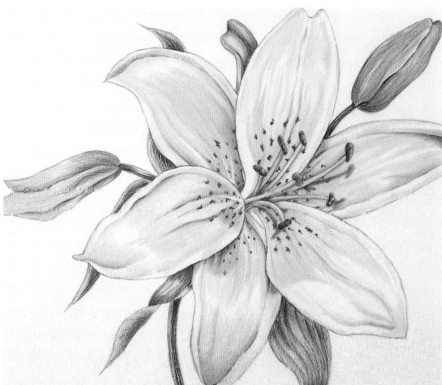

4 Sharpen and Refine the Image

With a very sharp Verithin Tuscan Red and Vermilion, edge and define the stamens and pistil in the center of the flower. Keep the defining edge clean and thin.

Using circular strokes, texturize the tips of the stamens with Verithin Tuscan Red and Golden Brown, followed by Black Grape. Apply the fine tip of the Colorless Blender marker to the stalks and tips just enough to liquefy and blend the color. Add Verithin Vermilion to the top of the pistil and blend in the same manner with the fine tip of the Colorless Blender marker.

Use the thick lead Tuscan Red with heavy pressure to indicate the irregular speckles on the petals, then apply the fine tip of the Colorless Blender marker to them, going outside of each speckle just a little to lightly smear the color and avoid a uniform polka dot effect.

5 | Prepare the Masking Film

Place a piece of masking film, shiny side up and paper side down, over the lily. With the permanent marker, trace the outline of the lily, the buds, stems and leaves. It's important that you use a permanent marker in this step (rather than one that is water-based) so that the ink dries quickly and doesn't smudge.

6 | Spatter the Background

Cut out the entire lily, and the two small negative areas inside it, from the masking film.

Peel away the paper backing from the masking film cutout and lightly press the protective pattern in place over the lily and leaves, matching lines and edges.

Load the toothbrush with Albrecht Dürer Canary Yellow by wetting the toothbrush with water and running the water-soluble pencil back and forth across the damp toothbrush. Blot it lightly on a tissue. Placing your thumb along the edge of the bristles and using the lily as the epicenter, flick the yellow pigment across the white background, radiating around and out from the picture. Redampen the toothbrush, reload with pigment, reblot and continue to spatter until the entire background is covered evenly with yellow. If any droplets are too large, don't blot them. Instead, touch a corner of the tissue to the oversized droplet and wick away the excess moisture.

Complete the background with a layer of Wine Red and last a layer of Mauve. Allow each layer to dry at least ten minutes before spattering on a new color.

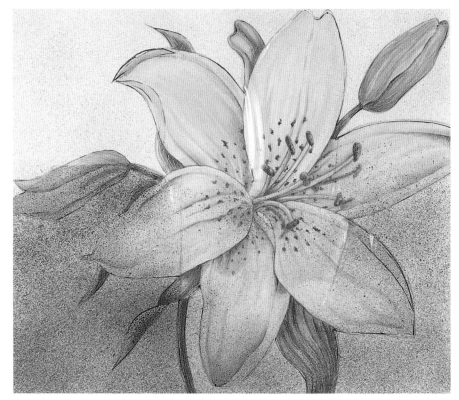

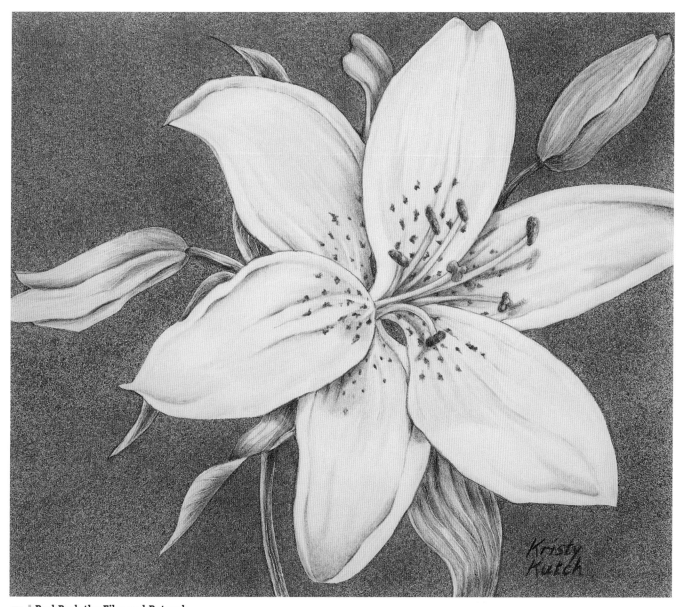

7 | Peel Back the Film and Retouch

Allow the background to dry completely. Gently pull back an edge of the masking film and peel it away. You can save it on a piece of foil, in case it becomes necessary to reposition and reuse it.

Retouch any spots where the film may have lifted the colored pencil. In any areas where the pattern extended beyond the lily and left white spaces, randomly dot in the background colors with a dry, and very sharp, water-soluble pencil, matching the spatters.

Define and sharpen edges with Verithin Lavender or Tuscan Red.

Mist with several light coats of ultraviolet light resistant spray in a well-ventilated area.

GOLDEN LILY | Kristy A. Kutch, CPSA | 8" x 9" (20cm x 23cm) | Colored pencil and water-soluble colored pencil on 115-lb. (240gsm) watercolor paper | Collection of the artist

Understanding Ink

Unlike watercolor, ink cannot be manipulated once it dries on the paper surface. Ink stays put. So you must be careful where you put it. As ink dries, it develops an edge of more concentrated color. Ink can be thinned with water to produce a range of values, but when mixed with greater and greater amounts of water, it becomes less and less waterproof. At the same time, it becomes more vulnerable to changes affected by its combination with other mediums, and to lifting methods such as eraser, adhesive tape, mounting putty, art knife, etc.

Due to the dyes from which they are made, many of the colored inks, especially the bright ones, are notorious for being fugitive, which means they fade over time. When I use ink, I mix colors that are dull and use them for their gray value. Once the ink is dry I then apply colored pencil over the ink to enhance and enrich the color. See page 38 for more information on the brushes and surfaces that work with ink and other watermedia.

Pens

Pens are marking instruments that contain some kind of reservoir for holding a liquid medium. Usually pressing the nib to your drawing surface releases the liquid and allows it to move from the reservoir to the nib (point/tip) and then flow onto your paper. The shape of the nib influences the distinctive mark made by the liquid.

CHARACTERISTICS OF INK

- Most colored inks are not particularly lightfast.
- India ink washes make excellent values for grisaille.
- Once ink dries it becomes permanent.

India (Black) Ink
India ink contains carbon particles suspended in a fluid binder composed of water and shellac or latex. India ink is opaque and very black when used full strength.

Colored Inks
Colored inks derive their color from dyes. Ink is permanent, but that doesn't mean it is lightfast. It means it is waterproof. The colors are often fugitive, and can fade in time.

Technical Pen

Outlining is easy if you use a technical pen, but you'll need to clean the pen often to keep it working well. Technical pens look like fountain pens, but the nib is a hollow tube with a thin wire inside of it. The wire moves back and forth, allowing the ink to flow out of the tube. The wire is extremely vulnerable and you should take great care of it when cleaning the pen. A bent wire will clog the tube and prevent the flow of ink. These pens contain reservoirs that are filled easily. You can use colored inks and India inks in the technical pen. The easiest brand of technical pen to use and care for is the Koh-I-Noor Rapidograph. Nibs are available in sizes that range from no. 6x0/.13 that creates an extremely thin line, to no. 7/2.00 that creates a very thick line.

Crow Quill Pen

The crow quill pen (above) also has a split nib that allows ink to flow from its tip. The curve of the quill acts as the only reservoir, so you must dip the entire nib repeatedly into your ink container to keep it full and keep the ink flowing. Originally these pens were made from actual bird quill feathers. Now the interchangeable nibs are made of extremely flexible metal and the handles usually are made of plastic.

Speedball Pen

A Speedball pen (left) has interchangeable nibs to create lines of different widths and shapes. These inexpensive pens are usually used for calligraphy, but they can also be used for drawing and sketching. The nib is split, allowing the flow of ink from the reservoir. As you press the pen point to the drawing surface, the two sections spread apart, and the ink flows. Ink is held in the reservoir by capillary attraction. However, the reservoir is small and you must fill it often. A dropper stopper, or a container with a tiny spout, works very well for this purpose.

Brushes and Other Applicators

Depending upon the effect you want to produce, any brush works with inks. Just be sure to clean it well and don't allow ink to dry in it. Dried ink is just as permanent in brushes as it is on paper.

Foam brushes, cotton swabs, tree branches and meat sticks all dispense ink to greater or lesser degrees and exhibit their own unique marks.

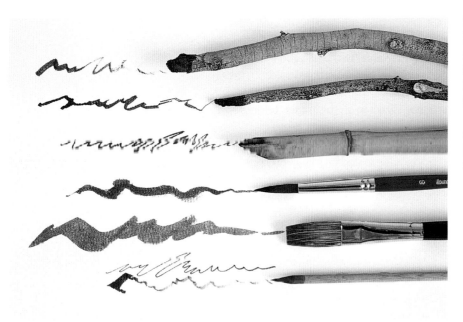

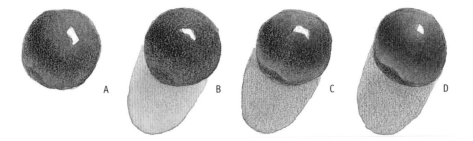

A B C D

3 | Complete the Grapes With Colored Pencil

Each grape is different from all the others, so complete the grapes by varying the color combinations slightly. Establish the contours with the darkest values, enrich the local color with the midtones. Create the *bloom* on the grapes with Cloud Blue.

Start by developing the contours of the grapes with the darkest values: Black Grape, Black Cherry, Tuscan Red and Dark Purple (A).

Enrich the local color mix with the midtones: Henna, Terra Cotta, Tuscan Red and Slate Grey (B).

Add the light and the bloom with the lightest value: Cloud Blue (C).

Using circular strokes, go over the entire grape with the Colorless Blender to smooth and even the color (D). Work from light to dark, but check the pencil point often and, if it picks up color, wipe it on a tissue so that you don't transfer color where you don't want it.

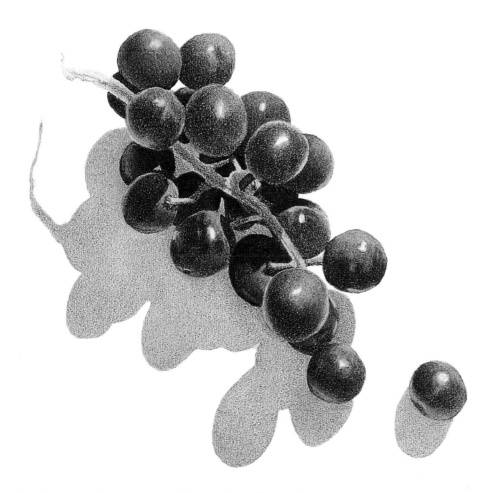

4 | Complete the Cast Shadow and Stem With Colored Pencil

First, in the part of the cast shadow closest to the grapes, lightly layer a combination of Rosy Beige and Deco Orange to suggest the reflected color of the grapes. Reduce pressure toward the outside edge of the shadow to gradually lighten the application.

Second, layer Slate Grey evenly over the entire shadow.

Third, go back into the shadow nearest the grapes and boost the reflected color with a light layer of Terra Cotta.

Apply a light layer of Limepeel to the entire stem to establish a base for the other colors. Then go back over the stem and apply Olive Green to create value changes as shown. Apply Goldenrod and Terra Cotta to warm the greens. Then add Black Grape to suggest the shadows and value changes. Apply it right over the other colors to darken them as needed. It will mellow the other colors and allow them to look more natural.

PRELUDE | Jamie Gildow, CPSA | 7" x 7" (18cm x 18cm) | Colored pencil and ink on hot-pressed watercolor paper | Collection of the artist

Demonstration | **Ink**

STELLER'S JAY | Sueellen Ross

Layering one medium over another has several distinct benefits beyond using just one medium. In this exercise, you'll apply black ink to the darkest parts of your graphite pencil drawing, build a gray tonal painting with watercolor (grisaille, see page 22), apply watercolor for color, then finally apply colored pencil for added richness and detail. Your benefits include speedy application of value and color with the liquid mediums, greater punch with contrast produced by the dark black ink, and the ease with which you can fix mistakes by covering one medium with another.

Surface
140-lb. (300gsm) hot-pressed watercolor paper

Brush
no. 4 round

Ink
FW Acrylic Black

Watercolor
Burnt Umber, Indigo

Acrylic
Liquitex Medium Viscosity Acrylic: Neutral Gray—Value 5/ Mixing Gray

Prismacolor Colored Pencils
Cream, Indigo Blue, Light Umber, Sand, Sepia, True Blue, Ultramarine, White

Other
Graphite pencil

1 | **Develop the Values**

Sketch in your subject using a graphite pencil. This demonstration crops into a Steller's Jay standing on a wooden deck. Use black ink to indicate the shadows between the planks in the deck, the backs of the bird's legs and the deepest part of the shadows cast by its feathers.

Build the grisaille on the deck area and on the bird with the liquid acrylic, starting with a dark charcoal mix of acrylic and water. Add water to the paint as you apply lighter and lighter grays. Protect the very lightest areas of the wood by covering them with the wax-based White pencil.

2 | **Glaze With Watercolor**

Using the no. 4 round brush, wash pale Burnt Umber watercolor over the whole deck, warming up all the grays.

Wash Indigo watercolor over the whole bird except for the gray legs and the pure white highlights on the spines of a couple of feathers. The blue should be rich and dark, but not so dark that it obliterates the tonal variations of the grisaille underneath.

3 | Soften Watercolor Edges; Apply Colored Pencil

Erase all White and graphite pencil. Soften harsh watercolor edges with a brush and a little water and blot up the moisture with a tissue. Avoid the blue bird with your wet brush and tissue.

On each feather of the bird, add highlights with White pencil and blend the edges of the White with True Blue, Ultramarine and Indigo Blue pencils. The Indigo Blue pencil should blend perfectly with the Indigo watercolor. Start at the top so you don't smear the White with your hand as you go.

4 | Complete With Colored Pencil Detail

Add and soften color on the deck with Cream, Sand, Light Umber and Sepia pencils. Soften ink edges with the Sepia.

Finish the highlights on the bird's tail using the same White and blue pencils, starting with White, and blending edges from light to dark. Don't cover up the beautiful Indigo watercolor or the black ink with colored pencil. Use the colored pencil sparingly to add highlights only.

STELLER'S JAY ON DECK | Sueellen Ross | 3" x 3" (8cm x 8cm) | Colored pencil, ink, acrylic and watercolor on 140-lb. (300gsm) hot-pressed watercolor paper | Collection of Cathy Michaels

Understanding Acrylic

Colored Pencil and Watermedia

From the beefy viscosity of modeling paste to the sheerest and thinnest of transparent glazes, and all the steps in between, acrylic really delivers with color and permanency.

For all intents and purposes, acrylic is plastic paint. Pigment is suspended in a binder of synthetic resin that, when dry, is permanent, waterproof, resists cracking (because it's flexible) and doesn't discolor with age.

While wet, acrylic is water-soluble, which makes brush cleaning easy.

Paint Consistency

Acrylic is available in a variety of consistencies. Bottle colors are thin enough to be used in an airbrush or as transparent glazes. Jar colors are thin enough to pour and they resemble gouache. Tube colors are thick and pasty, and hold their shape like oil paints.

Additives

You can further manipulate the consistency of acrylic by mixing it with other substances.

Water thins acrylic, but too much water can break down the suspension of the pigment in the binder, changing the characteristics and plasticity of the paint.

Acrylic varnish thins the paint without changing its composition. It can also be used as a sealant when brushed over a finished painting or collage.

Acrylic gel is a much thicker version of the paint's binder and when added to

Types of Acrylic Paint

acrylic color, it will produce the characteristics of heavy oil paint.

Acrylic paste is even more viscous and excellent for heavy impasto (thick paint) applications.

All of the acrylic additives (except water) can be used as glue.

Keeping Your Paint Wet

Because acrylic is water-soluble, it dries quickly. Sometimes that's a blessing. Other times, it goes far beyond frustrating.

Retarder makes the paint mixture dry more slowly. That means you have more time to manipulate it before it becomes too dry to work with.

To further retard drying, keep a plant mister handy and periodically mist your palette with water. That keeps your paints from drying out before you have a chance to use them.

See page 38 for more information on the brushes and surfaces that work with acrylic and other watermedia.

An Acrylic Underpainting Can Unify Your Composition

Washes of acrylic paint lend their color and value to unify this sunny composition inspired by a trip to Hawaii. The acrylic color tints the white paper, providing an added depth of color to the piece. The colored pencil accents and underscores the soft glow created by the acrylics.

All outlining is done with a technical pen (size no. 1/.50). I used acrylic mixtures of yellow, blue and violet, and Prismacolor pencils: Henna, Terra Cotta, Burnt Ochre, Limepeel, Olive Green and Mediterranean Blue.

RELATIVITY | Janie Gildow, CPSA | 5" x 5" (13cm x 13cm) | Colored pencil and acrylic on 140-lb. (300gsm) hot-pressed watercolor paper | Collection of the artist

An Acrylic Underpainting Can Help Establish a Range of Values

This glass container has fascinated me ever since I bought it. Its charm lies in the distortions it produces and I'm continually putting new objects into it to see what shapes and colors those distortions will assume. In order to create a full range of values and keep my colors bright and rich on the black background, I used glazes of opaque white acrylic as an underpainting for some of the colored pencil. The white acrylic appears as the highlights on the glass and under the lightest areas of the apricots in the container. However, the single apricot "in perigee" is 100 percent colored pencil.

PERIGEE | Janie Gildow, CPSA | 10" x 8" (25cm x 20cm) | Colored pencil and acrylic on black LetraMax board | Collection of the artist

Demonstration | **Acrylic**

SWEET CHERRIES | Janie Gildow, CPSA

Combining colored pencil with liquid acrylic makes for juicy and exciting color. The liquid acrylic permeates paper fibers and stays bright and permanent.

A foundation of acrylic—anywhere from a transparent wash to a hefty layer of concentrated color to an application of thicker consistency—adds brilliance to colored pencil and increases your color palette accordingly.

It doesn't seem as though colored pencil would stick to the acrylic's plastic surface, but colored pencil layers quite nicely over it, and under it, too.

Surface
90-lb. (190gsm) Canson Mi-Teintes no. 431 Steel Gray paper

Soft Pastel
White

Brush
no. 5 round

Golden Transparent Acrylic Airbrush Colors
Blue (Phthalo Blue-Green Shade), brown (Red Oxide), orange (Naphthol Red Light), purple (Dioxazine Purple), red (Quinacridone Red)

Prismacolor Colored Pencils
Black, Black Cherry, Crimson Lake, Crimson Red, Indigo Blue, Limepeel, Olive Green, Scarlet Lake, Terra Cotta, Ultramarine, White, Yellow Chartreuse

Other
Drafting tape, kneaded eraser, white paper

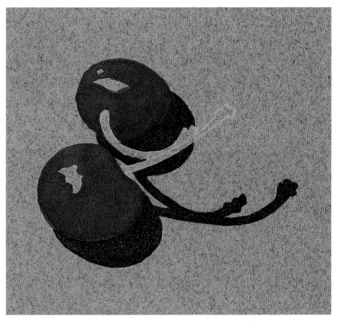

1 | Transfer Your Drawing; Begin the Shadows
Complete a sketch of sweet cherries on plain white paper (see page 133). Apply soft pastel to the back of your sketch. Position the sketch on the gray paper and tape it to the surface with masking or drafting tape. Use a colored pencil to trace over the lines transferring them to the gray surface.

Remove the pastel-backed drawing. Go over the lines lightly with white pencil. Use a kneaded eraser or piece of mounting putty to clean up the drawing and remove the pastel dust by pressing the lifter to the paper and pulling it away.

Apply a layer of Black pencil to the cast shadows. The pencil will contain and control the liquid acrylic you will apply next.

2 | Paint the Cherries and Cast Shadows
Mix red, orange and purple acrylic colors to create a cool red. Paint the cherries, but not their highlights.

Paint the cast shadows with a mix of blue, orange, brown and purple.

Check Your Color Mixtures

Judge your cherry and cast shadow color mixtures by comparing them to these mixes on white. Remember, color will look different when applied to gray paper.

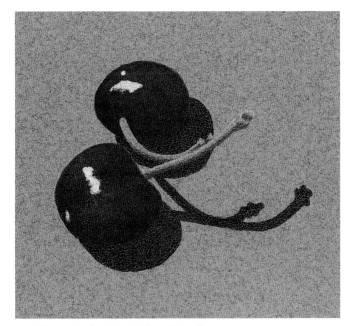

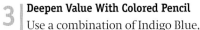

3 | Deepen Value With Colored Pencil

Use a combination of Indigo Blue, Black Cherry and Crimson Lake on the darker parts of the cherries to establish their contours and create the appearance of depth and dimension.

Use Indigo Blue to color the entire cast shadow.

Establish the darkest parts of the stems with Terra Cotta and Olive Green.

CONTROL YOUR PAINT

If you are frustrated with liquid mediums and find that they are hard to control, try applying a layer of colored pencil to the surface first. It's amazing how much control you will have as you paint right over the pencil.

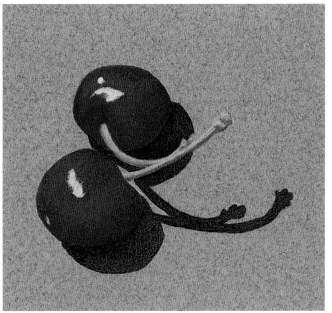

4 | Develop Rich Color With Colored Pencil

Apply a combination of Crimson Red and Scarlet Lake on the lighter parts of the cherries to create rich sumptuous color. Color the sharp-edged highlights with White to give the cherries sparkle and shine.

To enrich the cast shadow, apply Terra Cotta closest to the cherry, working toward the Ultramarine, and gradually reducing pressure. Layer Ultramarine on the part farthest from the cherry, working halfway back toward the cherry, and reducing pressure gradually. Color the lighter parts of the stems with a combination of Limepeel and Yellow Chartreuse.

SWEET CHERRIES | Janie Gildow, CPSA | 2" x 3"
(5cm x 8cm) | Colored pencil and acrylic on 90-lb.
(190gsm) Canson Mi-Teintes no. 431 Steel Gray paper |
Collection of the artist

Demonstration | **Acrylic**

ABSTRACT TAPESTRY | Dyanne Locati, CPSA

You can use acrylics in combination with colored pencils to produce exciting abstracts. As with many abstract works, this exercise cannot be exactly reproduced. However, you can use this easy technique to create something similar that will be your own unique art. As you become familiar with the procedure, you will develop your own style and way of working.

The goal is to produce the appearance of a tapestry or collage. Surface texture and line quality play an important role in this illusion.

In this exercise, you'll learn how to work with fluid acrylics. Using a scraper, you'll blend and move color, then use colored pencil to augment the shapes you've developed and create a complete composition. Work toward the image the composition suggests to you. Use colored pencil to weave color and complete the tapestry.

Surface
Museum-quality mat board

Golden Fluid Acrylic
Cerulean Blue Deep, Quinacridone Burnt Orange, Quinacridone Crimson

Prismacolor Colored Pencils
Apple Green, Black, Henna, Light Aqua, Mineral Orange, Peacock Blue, Sunburst Yellow, True Blue, White

Brushes
1-inch (25mm) flat acrylic brush

Other
Black gesso, fixative, pink eraser, scraper (cut portions of a smooth louver window blind about 2 inches [50mm] wide)

1 | Establish the Color Base

Randomly drop several dots of Cerulean Blue Deep across the mat board 2 to 3 inches (5cm to 8cm) down from the top. Don't cover the entire surface. Work quickly; don't allow the acrylic to dry. Repeat with each of the other two acrylic colors.

Place a plastic card or scraper at the top left-hand corner of the board. Use the flat side to pull down the page through the color. Lift the scraper off the bottom of the first column. Wipe off the excess paint, then repeat the process, moving across the board in vertical columns. Keep the layer of paint relatively thin. Colored pencil won't cover well on thick acrylic.

2 | Apply the Gesso

Place the tip of a wet flat brush in black gesso then brush a random design around the border of the composition. Dilute some of the gesso with more water and brush it onto areas of the surface of the painting. Allow the brush to dance. Don't cover all the white. Try not to have any preconceived ideas of how the finished painting will look at this point. Just allow your creativity to take over.

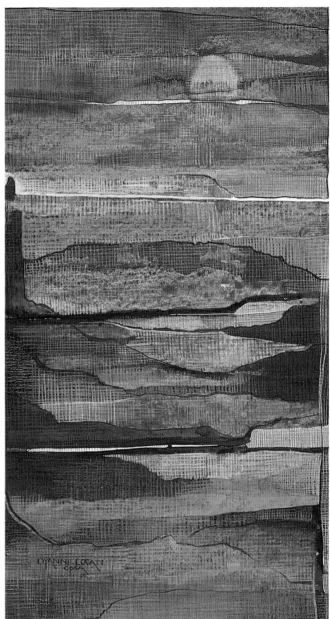

3 | Choose the Orientation and Add Colored Pencil

Now determine whether the composition will be horizontal or vertical. Turn it around and examine the shapes and color from all directions. Begin to think about the subject and look for specific shapes that suggest it.

Once you have chosen your view, use the various colored pencils to *weave* the color. Sharpen each pencil to a medium point and begin to draw lines. Make the stroke a comfortable length and draw carefully repeated lines across the surface—up and down, side to side. Determine the important shapes. Apply color to emphasize and de-emphasize shapes and to make them darker or lighter.

4 | Develop the Subject

Separate the divisions of space with color and line into foreground, middle ground and background. Draw a black line around important shapes in the painting. Develop a center of interest where the greatest differences (contrast, detail, texture, bright/dull color, etc.) appear. Don't isolate an area by color.

If you erase, use the pink eraser. At first the color will smear, but continue to erase the color until it's completely gone. The acrylic underpainting will act as a shield and the paper underneath won't be damaged.

The border plays an important role. Allow lines and shapes to flow from it into the landscape.

Spray fixative is optional, but not necessary.

GOLD HILL TAPESTRY | Dyanne Locati, CPSA |
17" x 10" (43cm x 25cm) | Colored pencil and acrylic
on mat board | Collection of the artist

Demonstration | Acrylic

STYLIZED LANDSCAPE | Priscilla Humay, CPSA

Working on wood is an exciting, and forgiving, way to paint and draw. The wood surface enables you to correct mistakes by simply sanding them away and redoing the area. The wood surface, colored pencil and acrylic medium are tough enough to handle reworking and portable enough for doing plein air (pronounced *playne air*, meaning to paint outdoors) artwork in any kind of weather.

In this exercise, you'll divide a horizontal (landscape) format into thirds, indicate a horizon line and locate a vanishing point. Add color by alternating layers of acrylic and colored pencil to complete this Florida inlet and early morning sky.

Surface
Maple wood panel

Prismacolor Colored Pencils
Black Grape, Dark Umber, Deco Aqua, Deco Blue, Deco Yellow, Marine Green, Pale Vermilion

Pablo Colored Pencils
Apricot, Aubergine, English Red, Naples Yellow, Olive Black, Prussian Blue, White

Liquitex Acrylic
Acra Crimson, Cadmium Red Medium, Cerulean Blue, Naples Yellow, Olive, Parchment, Twilight, White, Yellow

Brushes
no. 2, no. 10 sable rounds

Other
2B graphite pencil; acrylic medium; fixative; paper towel; small scrap of tan, very fine grit sandpaper

1 Draw the Composition With Colored Pencil

Use the 2B graphite pencil to render the composition on the wood surface (see page 134). Draw it dark enough to see, but light enough so that you don't impress the lines into the wood. If you need to erase, use sandpaper to softly sand the area away.

Use Black Grape and Dark Umber colored pencil to draw the intricate contours and establish the darker values in the shadowed areas of the cloud formations. With a light and even touch, apply the same colors to the shadowed areas of the tree line, the grass, and where the water meets the grass. This strengthens their dark values. Layer Black Grape in a horizontal gradation of tone along the very top of the composition where the band of cloud cover runs horizontally.

Use vertical strokes to block in the grassy areas with Marine Green.

Softly layer the sky with Deco Aqua leaving some areas free for later paint application.

Apply Pale Vermilion and a touch of Deco Yellow to the top of the sky and to the sky nearest the horizon.

Begin to suggest the reflections in the water with narrow vertical shapes of lightly stroked horizontal lines of Pale Vermilion, Marine Green and Black Grape. The reflections should be a muted mirror image of the shapes above the horizon line.

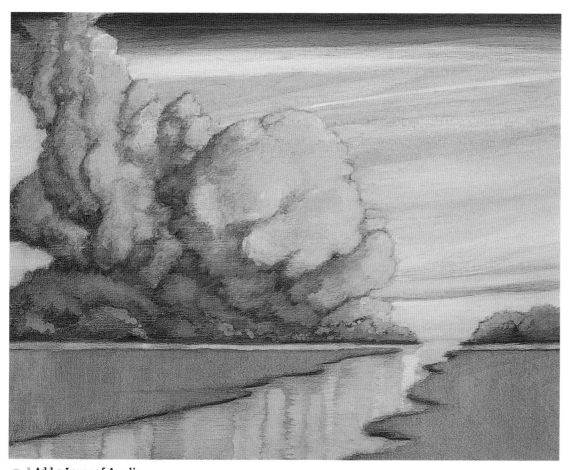

2 | Add a Layer of Acrylic

Prepare to paint all areas with a base of acrylic paint thinned with water. Keep the mixture thin enough so that your initial drawing remains visible. This procedure swells the wood fibers and adds surface texture that will grab the next application of colored pencil. Apply the paint with a no. 10 round brush. Using your fingers, smudge the paint to soften lines and blend color.

Paint a wash of thinned Acra Crimson on the undersides of the cloud formations to intensify the dark values. Paint a wash of thinned Cadmium Red Medium next to the areas of crimson and overlap them slightly in some areas with a feathered brush stroke. Leave the lightest cloud areas alone.

Apply thinned Olive to the trees, and with vertical upward strokes, to the grass to create a more natural growth pattern. Use the same color to paint in the areas of water between the reflections.

Then touch the tops of trees and clouds with thinned Parchment to give them a sunlit appearance. Use the same color on the striated clouds in the blue sky.

Reinforce the dark values in the upper horizontal band of clouds by washing in a layer of thinned Twilight. With the same color, carefully paint in to reestablish all dark values in shadowed areas of clouds, trees and grass. Then ever so softly, bring that thinned color into the water reflections, blotting up excess color with a paper towel if necessary.

3 | Apply More Colored Pencil for Value and Interest

Draw vertical soft strokes in the grass with Olive Black and with touches of English Red. Then draw in the shadowed areas with Prussian Blue and Black Grape to darken their values.

Layer Olive Black on the shadowed areas of the trees to bring out the lighter areas. Suggest sunshine on the tops of some of the trees with Apricot and Naples Yellow.

Using steady horizontal strokes, apply the dark values in the top horizontal band of sky with Aubergine and Black Grape. Work for a smooth transition of color.

With horizontal strokes, layer in the sky with Deco Blue. Then brighten the cloud strata with horizontal strokes of Naples Yellow making sure to maintain a soft and subtle change. Layer sunlit areas of cloud with White and Naples Yellow using soft strokes to create a billowy effect. Use gentle strokes of Naples Yellow to soften the water reflections.

Using Apricot, go back into the cloud areas to bring about a gentle transition from dark to light.

To dramatize the cloud areas, intensify them with English Red, Aubergine, Pale Vermilion and Black Grape. Add a touch of Prussian Blue, Olive Black and Black Grape to some of the dark areas to emphasize the values and unify the composition.

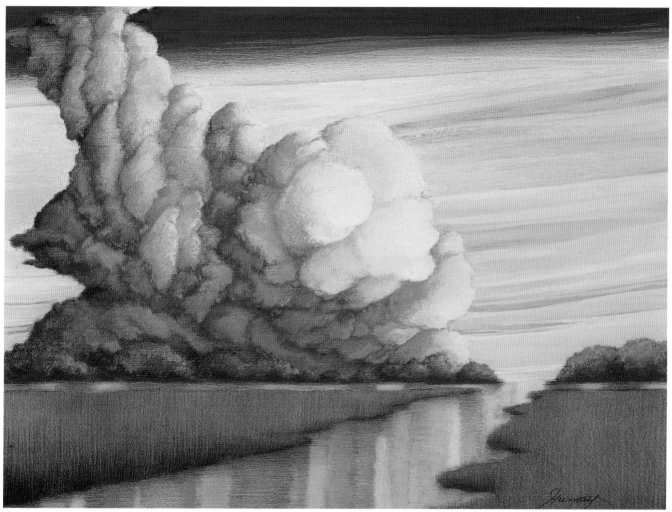

4 | Refine, Soften and Define With Acrylic and Colored Pencil

Use a no. 10 round brush to paint the uppermost dark and shadowed clouds with Twilight. Smooth with a brush or fingertips. Use the no. 10 brush to paint Cadmium Red Medium and Naples Yellow into the clouds to reinforce the vibrant concentration of color. Draw into the clouds with Pale Vermilion to bring out the reds.

Using an opaque mix of Cerulean Blue and White, block in the striated sky. Paint the rest of that sky with Naples Yellow and Parchment to allow for a smooth surface, carrying these colors into the reflections, clouds and the horizon.

With the no. 2 brush, define the dark billows in the clouds by painting touches of Twilight, Acra Crimson and Cadmium Red Medium. Define the light billows in the clouds by painting touches of Naples Yellow. Bring out the highlights with Parchment over the Naples Yellow.

Use a no. 2 round brush to apply Twilight to the undersides of the trees and the shoreline to define the darkest darks. With the no. 10 brush, layer Olive over the grass and tree areas. With firmer vertical strokes, draw over the grass using Black Grape, Olive Black and slight touches of English Red.

Apply a thin layer of Olive paint to the areas in the water that do not contain light or dark reflections. Soften the water and reflections with colored pencil using smooth strokes to apply Deco Blue and Naples Yellow to light areas, and Marine Green and Black Grape to dark areas.

MATANZAS SKY | Priscilla Humay, CPSA | 9" x 12" (23cm x 30cm) | Colored pencil and acrylic on a maple wood panel | Collection of the artist

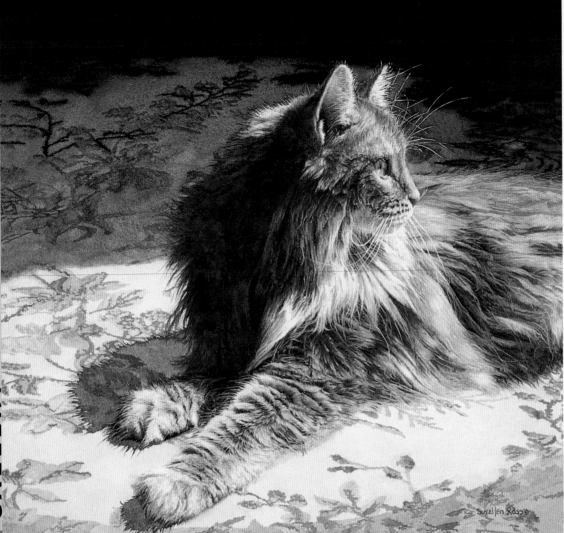

68

Dramatic Contrast Draws in the Viewer

Bright sun and deep rich shadow emphasize the soft fur of this attentive
cat. Sueellen uses a combination of brushed-on values, colored washes
and colored pencil to create wonderfully realistic subjects. Her under-
standing of value and contrast creates drama and establishes the lifelike
nature of this picture. The effects of sun and shadow are so successful
that we actually believe we are there.

SUN KISSED | Sueellen Ross | 14" x 13" (36cm x
33cm) | Colored pencil, ink and watercolor on 140-lb.
(300gsm) hot-pressed watercolor paper | Collection of
Simon and Dobbsie Koeman

Cropping Creates a Strong Composition

Barbara sees glorious color in everything and, best of all, is able to
reproduce it so that we see it in the same way. The strength of this com-
position lies in its no-nonsense cropping and its marvelous color. The
partial shape of an object is sufficient indication for us to know the
entire object is there. The lush yellow-green of the apples is repeated
throughout the composition, but in a softer and more muted form, serv-
ing to reinforce its strength.

First Barbara applied watercolor washes as a color base for the
objects and shadows. Careful layers of colored pencil then enriched and
augmented the washes, completing this elegant piece.

SIGNS OF LIFE | Barbara Benedetti Newton, CPSA |
18" x 13" (46cm x 33cm) | Colored pencil and
waterFcolor on 140-lb. (300gsm) hot-pressed watercol-
or paper | Private collection

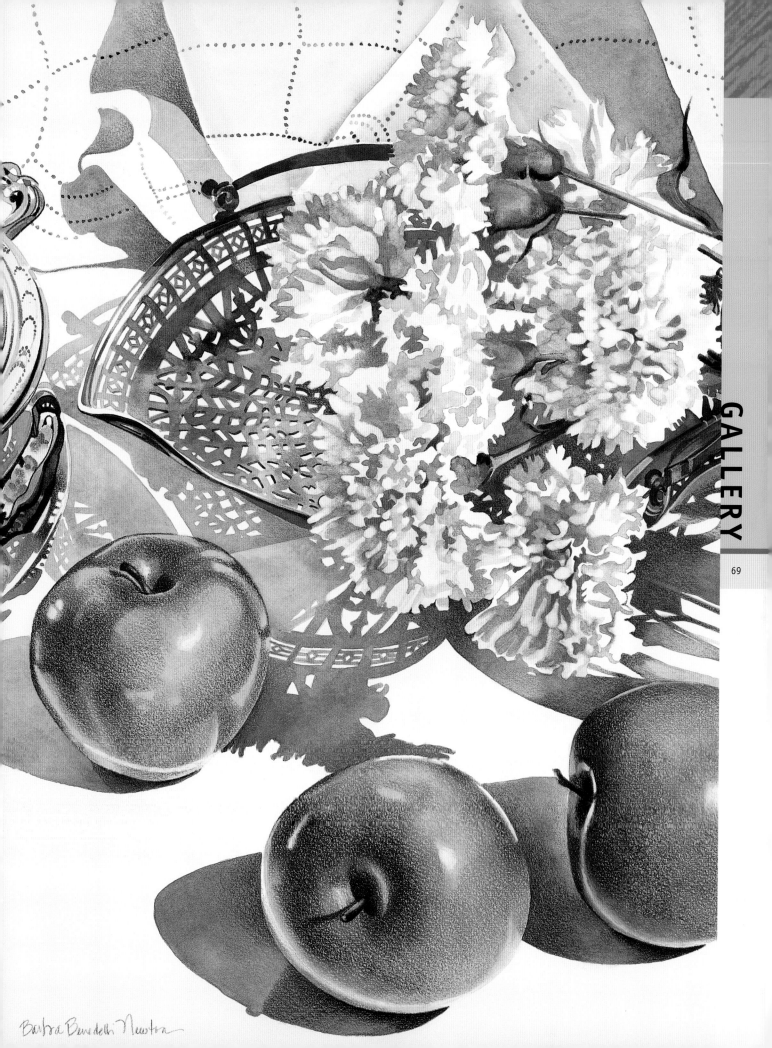

Barbra Benedetti Newton

Color Evokes Mood

Sylvia has captured a moment in time and shares it with us. Her limited color palette evokes a somber mood and the rich variety of effects and delicate details give this painting its innovative spark. The composition is exquisite. The shape of the rock under the raven is echoed (but reversed) in the dark clouds above. The raven stands out against the sky, light against dark and dark against light.

Sylvia uses several different mediums to achieve her goal. First, working back and forth with colored pencil and gouache, she completed the grass. She painted the rock area under the raven with sepia and black ink, then worked over it with colored pencil. The dark ink ground enabled the pencil colors applied over it to pop. The sky is a light watercolor wash mixed with soluble graphite pencil followed by colored pencil for detail.

RAVEN'S MORN | Sylvia Westgard, CPSA | 19" x 24"
(48cm x 61cm) | Colored pencil, ink, gouache and
water-soluble pencil on 140-lb. (300gsm) watercolor
paper | Collection of the artist

Ink Brings Delicate Grace to a Painting

Gray ink applied with a flexible crow quill pen lends a delicate touch to this tiny bird in its woodland setting. The ink provides a value base for subsequent applications of colored pencil. Barbara captures our attention with a color-filled *window* containing the subject along with graceful accents of lavender that compliment the warm earth tones.

CHICKADEE IN A WOODLAND WINDOW |

Barbara Krans Jenkins | 22" x 15" (56cm x 38cm) |
Colored pencil and ink on Crescent no. 115 board with
hot-pressed Strathmore watercolor surface | Private
collection

(left) Ink Establishes a Full Range of Values

Marleen's play-on-words title contributes to the eye-catching nature of this elegant composition. Black ink applied full strength with a brush to the entire background provides a full range of values to the piece. Ink was then drybrushed to all but the lightest areas of the subject to establish the values (grisaille). To complete the dramatic piece, Marleen applied several layers of colored pencil over the objects to produce the radiant color.

A PAIR AND AN APPLE | Marleen C. Higginbotham | 12" x 9" (30cm x 23cm) | Colored pencil and FW black ink on 140-lb. (300gsm) watercolor paper | Collection of the artist

(right) Textural Contrast and Limited Color Achieve Harmony

A nearly symmetrical balance of imagery and symbols unifies this composition. Richard skillfully used limited color and striking contrasts to achieve these distinctive harmonies. He masked the foreground with acetate and applied acrylic paint in a heavy impasto to the background with a palette knife. Next he airbrushed liquid acrylic over the impasto to achieve the tonal gradations. After removing the mask, he rendered the foreground exclusively in heavily burnished colored pencil. He applied a light tint of colored pencil to the background to complete the painting.

COMMUNICATION | Richard Mandrachio | 12" x 9" (30cm x 23cm) | Colored pencil and acrylic on cold-pressed illustration board | Collection of the artist

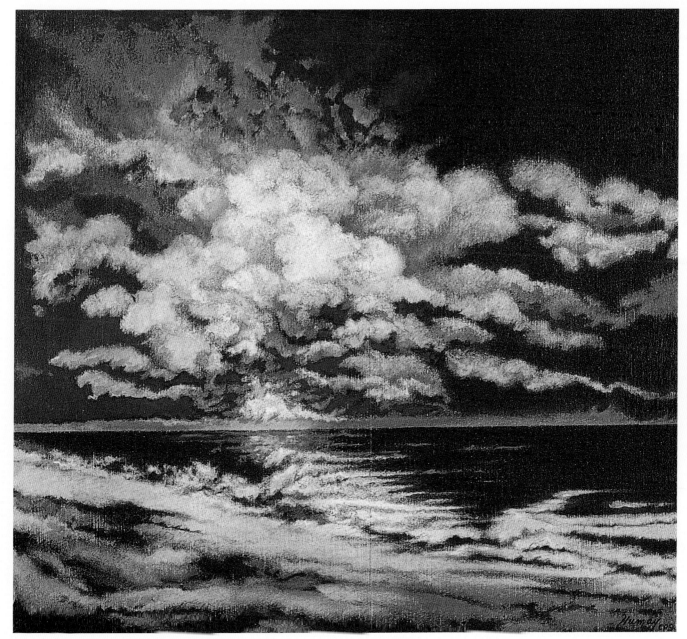

Vibrant Color Transports the Viewer to Another World

Bold contrasts and creative color set this skyscape apart. A rush of movement takes us from the calm foreground to the horizon and sweeps us into the billowing clouds above as Priscilla transports us to her world of exuberant color. The composition is unified by the use of related shapes and limited colors. *Red Islands in the Sky* was created from personal observation and sketches. It was sketched on wood, and completed with colored and graphite pencils and acrylics. Thinned mixtures of acrylics and water were applied to reinforce some areas and swell the wood fiber, giving more tooth to the surface. Full-strength acrylic paints created the intensity of color in the sky, water and land. Lastly, Priscilla applied acrylics alternately with colored pencils in a push-pull manner to refine and complete this powerful piece.

RED ISLANDS IN THE SKY | Priscilla Humay, CPSA | 11" x 11"
(28cm x 28cm) | Colored pencil and acrylic on a maple wood panel |
Collection of Laura Allen

Take your expertise a step farther and venture into the tantalizing realm of solvents. Solvent dissolves pencil wax and before you know it, you can push and spread the pigment. Build up heavy color, dissolve and move it. Experiment with the painterly effects you develop. Lift some of the color, add more color or do both. Solvents give you an easy alternative to paint—with colors the same as those you have in your pencil set.

Then give the airbrush a try. Use it to cover large areas with color, and also use it for what it does best: It's the master of the graded blend. Let it work for you to enhance and augment the colored pencil. Sure, it's more complicated than using a brush, but you can't duplicate its effects with anything else. Learning to use the airbrush is like learning to play the piano. The more you practice, the better you become. And the results are well worth it.

As you take your journey through this chapter, let the experts show you what they do and exactly how they do it. Follow along as they lead you step by step to develop the effects they achieve so well. Then adapt those effects to your own technique. Try them all—but most of all, play and have fun!

CHAPTER FOUR

CREATIVE EFFECTS WITH
Colored Pencil

GILMER ROAD | Susan L. Brooks, CPSA |
17" x 9" (43cm x 23cm) | Colored pencil,
pastel and solvent on sanded pastel paper |
Private collection

Understanding Solvents

A solvent is a liquid capable of dissolving another substance. In the case of art mediums, it is the binder that must be dissolved or liquefied, not the pigment.

The wax-based lead of the colored pencil can be dissolved with mineral solvents. The resulting mixture resembles paint. It stains the paper fibers and fills the paper tooth. It is a great way to fill large areas with color very quickly.

There are many kinds of solvents available to you and it is in their nature to be volatile.

Follow some simple procedures whenever you are dealing with them.

1| Work only with adequate ventilation. Don't breathe the vapors. The label may say odorless, but the smell and vapors are still there.

2| Keep solvents from coming in contact with your skin. If you must work *hands on* find yourself a pair of solvent-resistant gloves.

3| Always keep solvent containers closed when you aren't using them.

4| Store solvents in a cool place—preferably in a metal cabinet.

5| Store solvent-soaked cloths or paper in a metal container until you can dispose of them.

6| Use only the smallest amount of solvent necessary at one time. Pour a little into a very small bottle cap and replenish as needed.

7| Solvents are flammable or combustible, and what that means is that they contain vapors that readily ignite. Don't smoke or use matches anywhere near them and don't use solvents near heat.

8| It's also a good idea not to eat or drink while working with solvents for obvious reasons.

Turpenoid

This solvent dissolves colored pencil wax to produce exciting effects from light transparent washes to heavy saturated color resembling paint. Compared to water-based substances, it is less apt to cause warping and buckling as it permeates your paper or board surface.

Turpentine

This traditional solvent for oil paints is distilled from pine tree resin. It has a very strong odor and is flammable. It is the least appropriate for using with colored pencil because of its toxicity, volatile vapors, and the fact that it can be readily absorbed into the skin.

Mineral Spirits

This paint thinner is similar to turpentine and is combustible.

Citrus Thinner

This combustible solvent is a by-product of the production of citrus liqueur. It smells better than other solvents, but the citrus only masks the toxicity and combustibility.

Turpenoid works best as a solvent for colored pencil because it has the least odor.

Tools and Techniques

Working with solvents to produce differ-
ent effects only requires some practice
and imagination. Different tools give dif-
ferent results, so experiment to find
what you like.

Cosmetic Applicators and Brushes

Brushes and cotton or sponge cosmetic appli-
cators allow you to work with a limited amount
of solvent. Control with a cosmetic applicator is
less precise because it's more difficult to get
the applicator into small areas, but the applica-
tor delivers smooth blends of dissolved color in
large areas.

Brushes allow you to apply solvent in tiny
areas, but with them, an all-over application is
less smooth. Brushstrokes are much more evi-
dent and difficult to minimize.

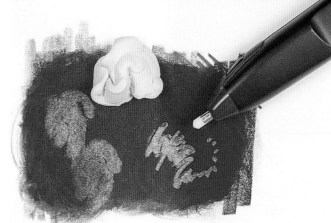

Lifting Dissolved Color

You can lift color with a battery-powered eraser. It removes color cleanly.
A kneaded eraser or mounting putty works as a color lifter in a limited
way, but don't rub the color with it. Instead, press it to the surface and
quickly pull it away to lighten color.

Applying the Solvent

No matter what kind of applicator or spreader you choose, as soon as you apply solvent with it, it
will begin to dissolve the pencil wax and the color will start to thin and move.

If you want color that looks smooth and even, build up substantial layers of pencil before you
apply the solvent. You can add more pencil on top of solvent for smoother coverage, too. And if
you work with a limited amount of solvent, either in applicator or brush, you'll find that eventually
the applicator or spreader will become saturated with color. At that point, it will spread pigment
rather than thin it or pick it up.

Demonstration | **Solvent**

PLUM AND CHERRIES | Janie Gildow, CPSA

In this exercise, you'll create two different effects. First you'll layer color heavily on the background with colored pencil, then use a tiny bit of solvent on a nearly dry brush to partially dissolve the wax and move the pigment, leaving your brushstrokes evident. Then you'll layer color on the cherries and plum and float solvent over the color with a loaded brush for a much smoother application. These effects contrast visual texture between the smooth shiny fruit and the faux look of the background.

Surface
140-lb. (300gsm) hot-pressed watercolor paper

Brushes
no. 12 round, no. 6 filbert

Prismacolor Colored Pencils
Black Cherry, Chartreuse, Crimson Lake, Dark Purple, Deco Orange, Goldenrod, Greyed Lavender, Indigo Blue, Jade Green, Olive Green, Peacock Blue, Poppy Red, Sunburst Yellow, Terra Cotta, Tuscan Red

Other
Odorless turpenoid, paper towels

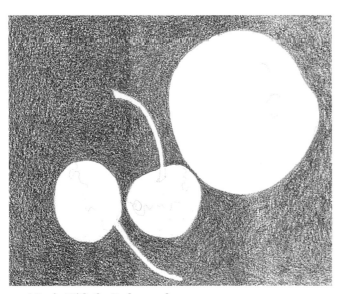

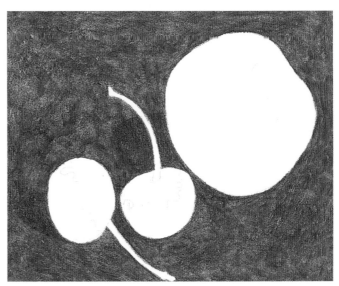

1 | Begin With the Background
Transfer the line drawing to your white paper (see page 134). Then begin the color foundation in the background by layering Black Cherry over the entire background, followed by Peacock Blue and Tuscan Red. Go ahead and let your pencil point get somewhat dull, but rotate it often so that you are coloring with an edge. That keeps your application even.

2 | Dissolve and Move the Color
Pour a small amount of solvent into a disposable cap or lid. I use the cap from a plastic 35mm film container.

Dip the round brush in the solvent and blot it on a paper towel to remove any excess. Try to keep enough solvent in the brush to wet the color but not soak the paper—almost a dry brush effect, but with a bit more liquid. Apply the solvent to the layered color of the background using small strokes in different directions (scumbling). Let your brushstrokes show.

Darken the cast shadows with a heavy application of Indigo Blue. You can start working immediately without waiting for the solvent to dry, but if you do, you'll find that the colored pencil won't go on quite so smoothly. If you let the solvent dry, the residual vapors will be gone, and the *solved* areas won't begin to dissolve the tip of your pencil.

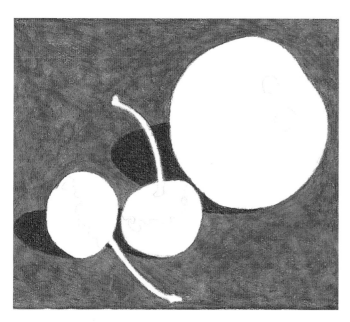

Blend the Color

Go back into the background with Greyed Lavender. Don't color the cast shadows. Use medium to heavy pressure and sharpen your pencil often. The pencil will glide over the solvent, but because the paper tooth is now more slick, it will be harder to build up color. The Greyed Lavender will lighten the dissolved color, and will blend and soften the strokes left by the brush.

Apply a layer of Dark Purple to the cast shadows using heavy pressure.

Start the Plum With Colored Pencil

Layer Black Cherry over the entire plum, avoiding the highlights. Reduce pressure and layer more lightly around the highlights. Then apply a layer of Tuscan Red on top of the Black Cherry in exactly the same manner to establish the local color of the plum.

Dissolve and Blend Color

Make sure the filbert brush is clean. Infuse the brush with fresh solvent. Apply it around the highlights first, so that the spreading color is faint. Then work outward toward the darker part of the plum. As you work, the brush will pick up and transfer color. Work to keep your strokes smooth. You can go back over them to smooth the color. If the brush picks up too much pigment, wipe it on a paper towel. Try not to add more solvent or you may remove too much color.

Complete With Colored Pencil

Apply a layer of Indigo Blue over the plum. Use heavy pressure around the edge and toward the center but reduce pressure around the highlights.

7 | **Create a Color Base for the Cherries**
Apply a substantial amount of Sunburst Yellow to the entire cherry with medium to heavy pressure, avoiding the highlight.

8 | **Darken the Color**
Over the Sunburst Yellow, lightly layer Greyed Lavender to dull and darken the yellow and make it look more natural.

9 | **Dissolve the Color**
Replenish used solvent with fresh. Dip the filbert brush into the solvent, but this time don't blot it on the towel. Float the solvent onto the cherries and brush the color around until it's even. Allow to dry.

10 | **Add More Color**
Layer Deco Orange where the red and yellow parts of the cherry meet. The orange helps to make a smoother transition from the red to the yellow.

Color the entire stem with Chartreuse as a foundation for the local color.

11 | **Darken the Reds**
Layer Poppy Red over the red parts of the cherries and reduce pencil pressure when you reach the Deco Orange so that you create a smooth transition from the red to the orange.

Apply Terra Cotta to the left side of the stem, to establish the contour and suggest the shadow.

12 | **Give the Cherries Form**
Apply Crimson Lake over the Poppy Red in the same manner as done in step 11, lightening pressure into the Deco Orange.

Complete the shadow on the stem by layering Olive Green over the Terra Cotta.

13 | **Add More Dimension**
Darken the lower part of the cherry with Dark Purple. Don't color over all the Poppy Red; allow some of it to show near the orange.

Finish the stem with a layer of Goldenrod applied over the entire stem.

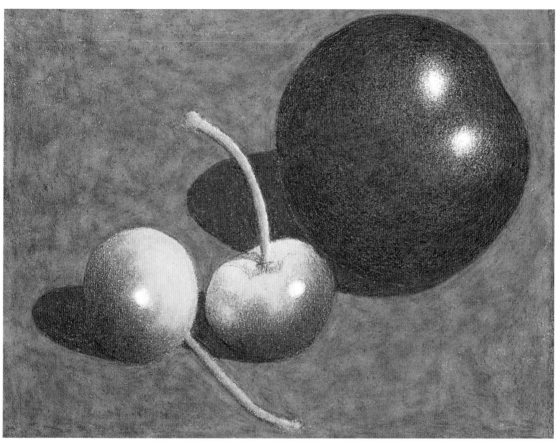

14 | Soften and Subdue the Background

Apply a medium to heavy layer of Jade Green over the entire background, except the cast shadows. This gray-green neutralizes the color and softens the strokes even more. The muted texture creates a nice contrast to the smooth shiny fruit.

Apply Jade Green very lightly to the cast shadows.

ROYAL TRIO | Janie Gildow, CPSA | 4" x 6" (10cm x 15cm) |
Colored pencil and solvent on 140-lb. (300gsm) hot-pressed
watercolor paper | Collection of the artist

Demonstration | **Solvent**

POODLE | Vera Curnow, CPSA

Unlike dry wax-based pigments, colored pencils blended with odorless mineral spirits (OMS) are more easily removed with an electric or battery-powered eraser. Cleaning up smudges and erasing errant lines is easy. The extra advantage is that you can blend your own custom background colors with the solvent.

In this exercise, you'll use your electric or battery-powered eraser as a drawing tool to lift color and reveal the lighter ground beneath it in a modified sgraffito technique (pronounced *scruf EE toe*, meaning to scratch lines down through a surface to reveal a different color ground beneath). Then you'll add colored pencil to embellish and enhance the reverse drawing.

Surface
Cold-pressed illustration board

Prismacolor Colored Pencils
Black, Canary Yellow, Cloud Blue, Cool Grey 30%, Cool Grey 50%, Dahlia Purple, Indigo Blue, Mulberry, Spanish Orange, Tuscan Red, Violet, Warm Grey 30%, Warm Grey 50%, White

Schwan Stabilo Aquarellable Colored Pencil
White

Other
Art knife, battery-powered or electric eraser, cosmetic pads, cotton swabs, OMS solvent

1 Cover the Board With Pigment
Neatness doesn't count in this process. The only thing that does matter is getting enough dry pigment on the paper so that it can be blended and dispersed. Use a colored pencil or its Art Stix equivalent to cover the entire surface with coarse layers (in this order) of Mulberry, Dahlia Purple, Violet, Tuscan Red, Indigo Blue and Black.

2 Blend the Color
Apply just enough OMS to a cotton cosmetic pad to moisten one side. The best way to do this is to dip a cotton swab into the solvent and wet the pad with it. You can always add more OMS if the pad becomes too dry. Rub firmly in various directions—circular, horizontal, vertical—so that there are no obvious streaks in the color blend.

3 | Draw the Poodle

You don't have to wait for the surface to dry. Draw the poodle head directly on the colored background with the White Stabilo pencil (see page 134).

4 | Erase the Subject

This is the fun part. Begin by erasing the lightest values first. Erasing over areas more than once will remove more color. Use less pressure to remove color from the medium values. The surface color serves as the darkest value. You can use a battery-operated eraser, but the electric version exerts more power and removes the pigment faster and deeper.

Use some yellow and black pencil to hold the placement of the eye and to avoid erasing in that area.

5 | Develop Values, Color and Detail

To develop contrast, keep erasing the lighter areas. For the details, a blunt eraser tip makes softer, fuzzier lines. Sharpen the tip on a piece of coarse paper or fine sandpaper for thinner, more delicate lines. Use a combination of both as you indicate the hair.

Layer Canary Yellow and Spanish Orange colored pencil for the eye. Keep the lower part of the front of the eye lighter than the top and back to indicate depth. Color the pupil black. Erase out the white highlight and punch up its white with the White pencil for a bright sparkle.

Use Black around the eye, on the nose and mouth and on the bottom of the ear to punch up the dark areas and develop contrast. Draw some dark hairs up into the middle of the ear with Black and some light ones down into the bottom with Cool Grey 50% to gradually blend values and make the hair appear more natural. Use the Warm Grey and Cool Grey 30%, Cloud Blue and White to

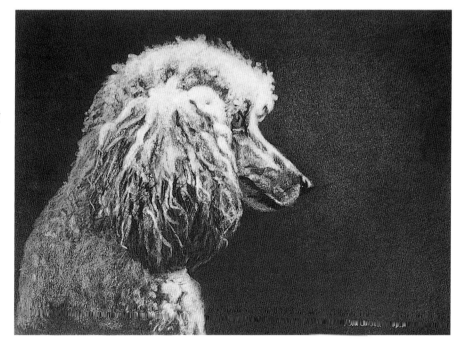

define the medium and light values.

Add some Indigo Blue to tone and deepen the background. As a final touch, use an art knife to scratch out color (sgraffito) and indicate the fine hairs in the face, nose and ear.

Use a blended eraser to lift a small amount of the concentrated background color from the area directly in front of the poodle's face for a subtle spotlight effect.

POODLE HEAD | Vera Curnow, CPSA | 7" x 10" (18cm x 25cm) | Colored pencil and solvent on cold-pressed illustration board | Collection of Ann and Steven Smith

Demonstration | **Solvent and Pastel**

LANDSCAPE | Susan L. Brooks, CPSA

Much of the joy of using colored pencils arises from the wonderful colors you can create by layering. Sanded pastel paper provides a tooth that allows the application of an incredible number of layers of color.

In this exercise, you'll apply a color base of pastel, spray the color with solvent and massage the powder into the surface. When you apply the colored pencil on top, your pencils will move smoothly across the surface of the painting laying down *glazes* of color. As you work, you'll need to respray your composition frequently with solvent. Pencil glazing works best when the surface is damp. Remember to use adequate ventilation.

This is a loose technique so don't expect to create an exact replica of the example, and do plan to put in some practice time before beginning your final composition.

Surface
Celadon Windberg sanded pastel paper

NuPastels
Burnt Carmine, Heather Pink, Soft Yellow

Rembrandt-Polycolor Colored Pencil
Rose Carmine

Derwent Artists Colored Pencils
Burnt Sienna, Chartreuse, Chinese White, Grape, Lime, Raw Sienna, Rust, Sunset Gold, Teal Blue

Pablo Colored Pencils
Golden Ochre, Indian Red, Khaki Green, Moss Green, Olive Black

Fullcolor Colored Pencils
Dark Orange, Ice Green, Indian Yellow, Light Ochre, Mauve, Old Rose, Sanguine

Polychromos Colored Pencils
Ivory, Light Carmine, Light Flesh, Light Orange, Mauve, Medium Flesh, Middle Cadmium Red, Rose Carmine, Rose Madder Lake, Tangerine

Prismacolor Colored Pencils
Aquamarine, Beige, Black Cherry, Blue Violet Lake, Cream, Dark Purple, Light Aqua, Light Cerulean Blue, Limepeel, Mineral Orange, Sunburst Yellow, True Blue, Tuscan Red

Other
3M Magic Tape, blending stumps or tortillions, empty travel-size hair spray bottle (must produce very fine mist), odorless turpenoid, sandpaper block

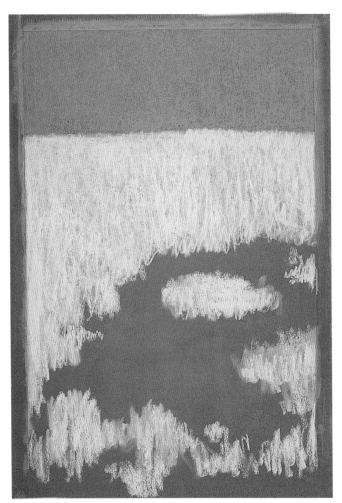

1 Prepare the Edges and Block in the Base Color
Transfer the line drawing to your paper (see page 135). Make a border by taping the edges of your paper. The taped edges not only stay clean, they help to define your composition.

Color the sky solidly with Heather Pink. Color the grasses with Soft Yellow.

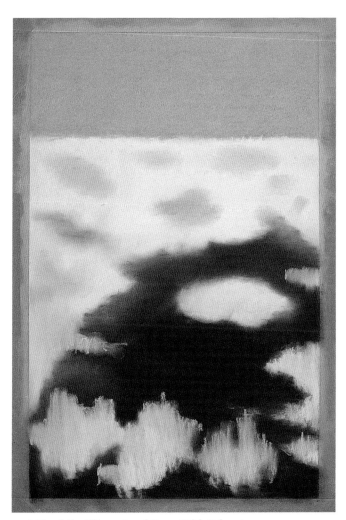

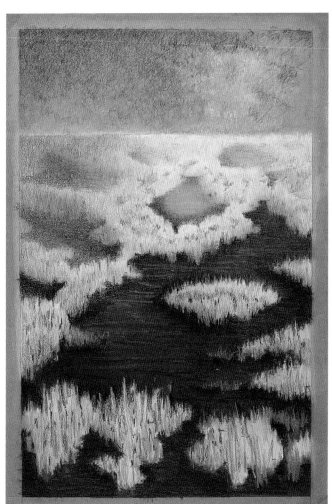

2 | Blend the Pigment and Spray With Solvent

Apply Burnt Carmine to the water areas. Turn the paper upside down over a wastebasket or piece of newspaper and lightly tap the back to remove the excess dust. Lightly mist the color with solvent and then reapply all the colors again. Use your fingers or a blending tortillion to *massage* the pigment into the paper. Be careful not to rub away the pigment; instead work it into the paper. Completely blend the sky, background and middle ground, but in the foreground, retain some of your individual strokes. With some of the Burnt Carmine on your fingers, color over the Soft Yellow to softly develop the areas of water near the horizon.

Spray more solvent over the pastel to prepare for colored pencil application.

3 | Begin Glazing With Colored Pencil

Working from top to bottom of your composition, add color to the sky. Scumble (see page 34, step 1) loosely with multiple layers of pinks, oranges, purples, blues, yellows, cream and white. Keep the concentration of darker colors at the top and left, and gradually lighten toward the horizon line and the moon. As the color dries, mist over it with solvent.

The grass is lighter and brighter nearer the moon. Use the lighter yellow-greens to develop clumps of grass and some of the dark areas.

Add some of the blues and blue greens to the grass and water near the horizon line on the left side of the composition.

The water surface gradually darkens toward the bottom of the composition. Work your way downward with horizontal strokes of Beige, Indian Yellow, Rust, Black Cherry and Grape. Keep the greatest concentration of the lighter colors in the middle ground and gradually change to the greatest concentration of darker colors near the bottom.

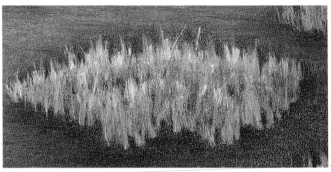

4 | Build Color in the Sky
Continue to add color to the sky using the same colors from step 3.

5 | Develop the Grass
Define the clumps of grass in the middle ground and foreground by coloring the negative areas around them with the darkest purples, oranges and greens. Use primarily vertical strokes. As the grasses begin to emerge, apply strokes of the medium-value colors (oranges, golds, greens and blue greens) to give them richness and character.

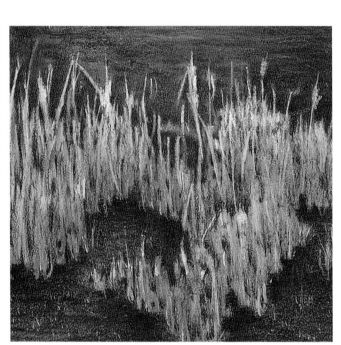

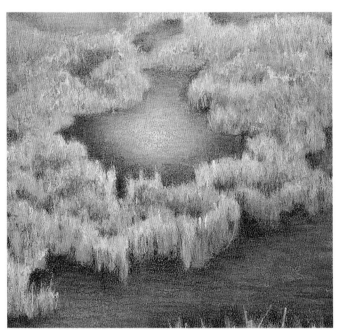

6 | Add Detail to the Grass
Layer some of the blue-greens and some of the dark reds in vertical strokes to add color to the grass. Use Beige, Ivory and Lime to isolate and brighten individual spikes.

7 | Color the Water
For the water nearest the moon, use True Blue and Light Cerulean Blue with touches of Old Rose, Middle Cadmium Red, Golden Ochre and Light Ochre. Blend the color with your fingers for smoothness if needed.

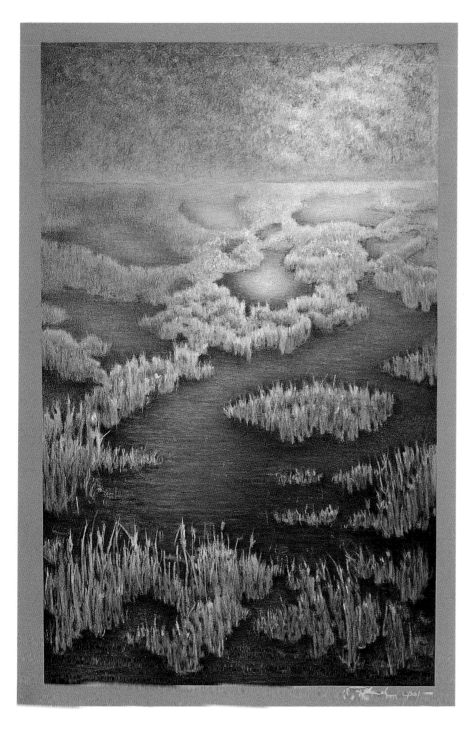

8 | Check Value and Color

Lean back and look at the composition as a whole. Lighten the clouds in front of the moon with Chinese White and Ivory. Punch up the light in the reflection of the moon on the water. Make sure the moonlight is brightest there and that you have darkened the edges of the water sufficiently to emphasize that area as the focal point.

Use Chinese White, Cream and Ivory to add moon glow to individual blades of grass.

Remove the tape for a clean border.

NOCTURNAL AWAKENINGS | Susan L. Brooks, CPSA | Colored pencil, pastel and solvent on sanded pastel paper | 18" x 11" (46cm x 28cm) | Collection of the artist

Understanding the Airbrush

Using the airbrush is easy and fun once you learn the basics. Like many other art techniques, airbrushing is a motor skill that must be learned so you'll need to practice until the moves come naturally.

It really doesn't matter what kind of airbrush you use because when you use it in combination with colored pencil, you aren't going to use it for detail or realism. You will use it as a means rather than an end. Let it help you establish large areas of color quickly. Or use it for creative effects rather than tight realism. I can't believe I said that!

How Does the Airbrush Work?

A vacuum created in the nozzle pulls the paint from the reservoir or cup to the needle. There it is mixed with compressed air to form a fine spray of tiny droplets that are released in a soft-edged circular pattern.

The main feature of the airbrush is the action. The action determines how the mixture of air and color are controlled.

Single-Action Airbrush

The trigger moves in only one direction—down. Pressing downward on it releases the spray which is a mixture of air and a preset amount of color.

Double-Action Airbrush

The double-action airbrush trigger has two separate movements—down and back. Pressing the trigger down begins the release of air; pulling the trigger back gradually releases the color. Both the size of the spray pattern and the volume of color are controlled by the trigger. Control is easier with a double-action airbrush.

Air Source

If you are going to use an airbrush, you'll need a source of pressurized air. There are many different kinds of compressors on the market with prices ranging from $150 to several hundreds of dollars. In general, expect the compressor to cost more than the airbrush.

When I bought my first airbrush, I kept cost to a minimum by using my husband's big red shop compressor for my air source. It had wheels and weighed a ton, and other than the very loud (and startling) intermittent noise it made in order to keep pressure in the tank, it worked just fine. I've graduated to a silent compressor now, and even though it cost quite a bit more, it's much more pleasant to work with, very convenient for what I need—and I don't have to take it back to the garage at the end of a painting session.

Cleaning

The single most important thing you can do if you use an airbrush is to know how to clean it, and to clean it *every* time you use it. Flush the airbrush with water or cleaner every time you change color or take a break. And clean it well at the end of every session. Thorough cleaning involves disassembling and reassembling the airbrush.

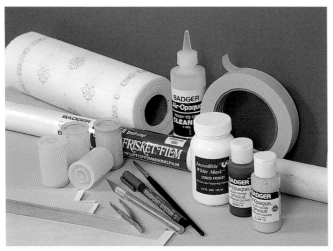

Tools and Equipment
(Clockwise from top center) Airbrush cleaner, drafting tape, liquid mask, airbrush paints, watercolor brush, fine-line permanent marker, art knife with a sharp blade, tweezers, border guards, extra containers, masking film (roll or sheet), paper towels and acetate (not pictured).

Taming the Airbrush
The airbrush looks pretty much like a fountain pen. Hold the airbrush like you would hold a pen and rest your finger on the trigger. Wrap the cord around your arm to keep it out of your way.

Masks and Stencils

Color is propelled from the airbrush nozzle in a circular pattern so even the smallest line you make will have soft edges. You'll need to use a masking material in order to make a sharp clean line or edge, and to cover some areas of your painting while you work on others.

Masking film is tacky on one side, transparent, adheres to your painting surface, and is easy to remove.

With a piece of masking film laying over your painting surface, use a sharp art knife to cut around the areas where you want color and then lift out those pieces. Make the cuts deep enough to cut through the film, but not deep enough to cut into the paper beneath. Make some practice cuts until you get the feel of how much pressure to use. Store the cut pieces on the backing paper so that you can use them again.

As you spray on the color, the remaining film protects the other areas of your painting.

You can move loose masks and stencils around by hand to create softer edges or outlines just where you want them. Hold the stencil away from the surface and paint along its edge. The farther you hold the stencil from the surface of your painting, the softer its painted edge will be.

Developing Color

Work on an inclined surface as it allows you to hold the airbrush in a natural position and better see your painting.

The airbrush can be used to lay down a flat even tone or establish local color, so it's excellent for laying in quick backgrounds.

Because the airbrush releases tiny droplets of color, it's easy to develop graded tones and gradually blended colors. The tiny dots allow the color of the surface, or of previous layers, to show through them. Like colored pencil, you mix colors by layering. The first color down will be the dominant color.

Other Tips

Cover your drawing board or table with plastic, scrap paper or an old sheet. It might be a good idea to cover the floor, too. I wear an apron.

Invest in an inexpensive airbrush holder that attaches to the table so that you have a place to put the airbrush when you set it down.

Keep a wastebasket lined with a plastic trash bag nearby.

SAFETY PRECAUTIONS

The airbrush produces a very fine mist of tiny colored droplets. Most of them end up on and around your painting surface, but some of them remain in the air for a while. To avoid breathing them, you should always wear a mask. Don't inhale the mist.

Wrinkle-Free Masks

For smaller pieces of film, you can remove the entire backing, hold the film in both hands, and position it on your paper.

For large pieces, first separate the film from the backing at one corner and fold down the backing all along one edge.

Attach the film at the top of your paper. Then just pull down the backing for a smooth wrinkle-free bond.

Softer Edges

Loose masks and stencils can be made from just about anything non-adhesive: acetate, stiff paper, card stock, templates or household objects.

YELLOW PEPPER | Janie Gildow, CPSA

The airbrush can save you a lot of time by laying down local color quickly. It's a miracle worker at developing graded tones, too.

In this exercise, first you'll paint flat tones to establish a color base. Then you'll use the airbrush freehand, and with an acetate stencil, to create sharp and soft edges, build up color and suggest volume. Finally you'll augment with colored pencil to complete the shiny pepper and its shadow in rich, sumptuous color.

Surface
140-lb. (300gsm) hot-pressed watercolor paper

Badger Air-Opaque Airbrush Colors
Brown, Chromium Oxide Green, Green, Indigo, Violet, Warm Yellow, Yellow

Brush
Small round watercolor brush

Prismacolor Colored Pencils
Apple Green, Black Cherry, Dark Green, Light Green, Limepeel, Olive Green, Peach, Pumpkin Orange, Spanish Orange, Terra Cotta, White

Other
Airbrush and compressor, art knife, black fine-line waterproof marker, border guards, containers with lids for storing mixed paint, drafting or low-tack tape, heavy acetate, liquid mask, masking film, paper towels, tweezers

Mix Your Colors

It's a good idea to mix all your airbrush colors before you start to paint. Use empty 35mm film canisters to store your paint so the colors you mix don't dry out. Once you have added the colors to your mixing container, add enough water to thin the mixture to the consistency of milk.

Stem Color

Mix nearly equal amounts of Green and Chromium Oxide Green. Add water to thin.

Pepper Colors

For the sunny yellow local color, make a mixture of Yellow and a tiny bit of Warm Yellow. Add water.

To make the darker contouring color, mix together Yellow, Warm Yellow and Brown. Then add a very small amount of Violet to mellow the mix. Add water.

Shadow Color

Mix together Indigo and a small amount of Yellow to neutralize the color just a bit. Thin with water.

1 | Prepare Your Paper
Draw the outline of the pepper onto a piece of masking film (larger than the image) with a fine-line marker (see page 135). Remove the backing from the masking film and attach the film to your paper. Use an art knife to cut along the lines of the pepper, essentially creating six shapes (see numbered shapes on page 135). Cut only the film, not your paper.

Position border guards (drafting tape applied to the long sides of paper strips, extending past the long edge by ⅛-inch [.32cm]) to overlap the outside edges of the film so that you don't deposit color on the margins or on your drawing board or desk while you paint.

2 | Prepare Your Stencil
Trace the separate contouring shapes within the pepper outline onto a square of heavy acetate larger than the line drawing. Cut the two shapes from the acetate and keep the large piece for use in step 5. Discard the two cutouts.

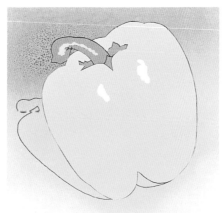

3 | **Lift the Film and Paint the Stem**
Remove masking film piece no. 1. Apply liquid mask to the highlight of the stem. Dry completely.

Load the airbrush with the stem color and develop color with several light coats. Allow to dry completely. Normally you would paint with your lightest color first and work toward the darkest, but it's less complicated here to begin with the green and finish it early on.

Remove the mask from the highlight with tweezers. Don't rub.

Flush the color from your airbrush.

4 | **Paint the Flat Tone**
Reattach masking film piece no.1. Remove masking film pieces nos. 2, 3 and 4. Apply liquid mask to the two outer white highlights on the pepper and allow it to dry completely. Paint the pepper with several light coats of the sunny yellow mixture to achieve an even color base. Allow to dry completely. Don't remove the mask yet.

5 | **Position Your Stencil**
Apply additional mask around the outside of the two outer highlights to protect a thin edge of yellow. Allow mask to dry.

Position the acetate stencil you created in step 2 over the pepper. Use the dotted lines on the stencil drawing (below, left) as guides for placing the stencil. Tape the top edge of the stencil down so that it's like a hinge. Roll up the bottom of the stencil so that it's slightly off the paper, but press the top of the stencil opening to the paper to make a harder edge along the top of the pepper. Keeping the bottom of the stencil up off the paper will allow you to follow its general outline and at the same time develop soft edges. Where it touches the top of the pepper, the edge you make will be harder.

Use the dotted lines as guides for placing your acetate stencil over the pepper.

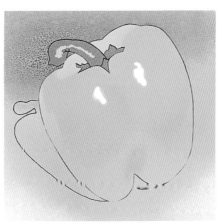

6 | **Contour the Pepper**
Paint around the outside of the stencil opening with your brownish-orange mix and freehand a darker shadow down the center. Apply a heavier concentration at the bottom of the large opening and in the small opening below it. Remove the taped stencil. Allow the paint to dry completely and then use tweezers to remove the mask from the highlights.

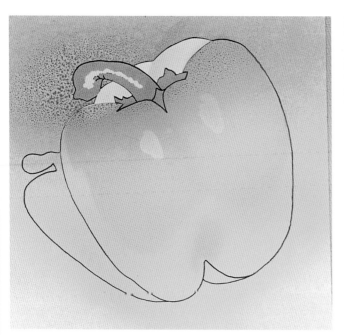

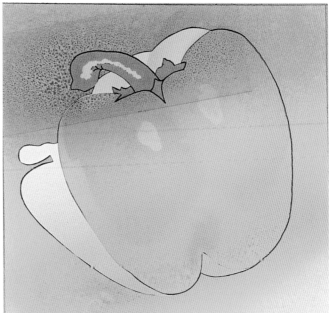

7 | Apply More Color

Reattach masking film piece no. 2. Line up one of the curves of the heavy acetate stencil to coincide with the contour shadow edge in shape 4. Hold the acetate slightly off the paper and paint the brownish-yellow mix against it to suggest the contour with a harder-edged line. Deepen the color of shape 3 to indicate it is in shadow. Allow to dry.

8 | Tint the Cast Shadow With Reflected Color

Take the backing off a scrap piece of masking film and cover shapes 3 and 4.

Remove stencil pieces nos. 5 and 6. Use the brownish-orange mix to paint shape 6 and the bottom half of shape 5. Grade the color in shape 5 to gradually diminish toward the top of the shape. The first color you put down with the airbrush is always the dominant color, so the orange will glow through the blue-gray that you will apply in step 9.

9 | Complete the Shadow

Flush the airbrush to remove the orange mix. Fill the airbrush with the blue-gray shadow color. Apply a graded tone in the opposite direction from the one you developed in the previous step so that the more concentrated and darker tone is at the top. Lightly mist some of the color into shape 6. Allow this to dry.

Remove all border guards and masking film to reveal the entire pepper and its shadow.

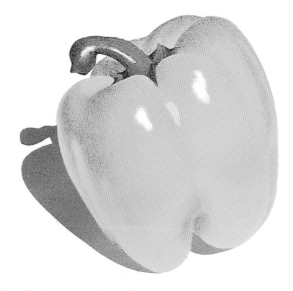

10 | **Add Colored Pencil**
Develop the shadows and contours of the stem with Black Cherry. Soften the edge of the stem's white highlight with Light Green. Then apply Apple Green to the entire stem, except for the highlight, to enrich the local color. Smooth any rough transitions with Dark Green.

Create a muted center highlight on the pepper with White. Then use Spanish Orange to soften the edges of the other two pepper highlights. Begin to indicate contours and edges on the pepper softly with Peach.

11 | **Add More Color**
Continue to develop the darker areas of the pepper by adding Pumpkin Orange and Terra Cotta over the Peach. Add a little Terra Cotta to the stem to mellow the green.

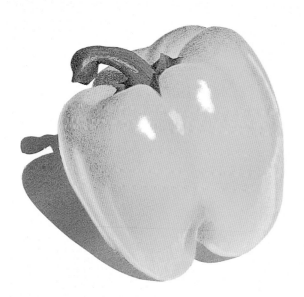

12 | **Complete the Pepper**
Darken and dull the shadows and values at the top of the pepper with Olive Green and Limepeel. Add Olive Green to the darkest areas and apply Limepeel over the Olive Green and into the lighter areas.

Add White to the bottom of the pepper and on the softer highlights along the sides to give the pepper even more gloss and shine.

Leave the cast shadow as it is to showcase the effect of the airbrush.

GOLD AND GLOSSY | Janie Gildow, CPSA | 4" x 4" (10cm x 10cm) | Colored pencil and airbrushed acrylic on 140-lb. (300gsm) hot-pressed watercolor paper | Collection of the artist

Demonstration | **Airbrush**

STRAWBERRY | Barbara Benedetti Newton, CPSA

Airbrushing a foundation for colored pencil is fast, easy and shaves hours off your work time. One of the challenges of working with air-brushed color is avoiding the mechanical look created by the hard edges of the stencil. In this exercise, you'll apply a color foundation with the airbrush, then use colored pencil to enrich color, add detail and provide a three-dimensional appearance to the strawberry.

Surface
140-lb. (300gsm) hot-pressed watercolor paper

Dr. Ph. Martin's Hydrus Fine Art Watercolors
Burnt Umber, Hansa Yellow Light, Indian Red, Permanent Red, Quinacridone Magenta, Sap Green, Ultramarine, Yellow Ochre

Brush
Small round watercolor brush

Derwent Artists Colored Pencils
Indigo Blue, Rioja

Polychromos Colored Pencils
Apple Green, Cedar Green, Grey Green, Peacock Blue

Prismacolor Colored Pencils
French Grey 50%, Jasmine Yellow, Poppy Red, White

Other
Art knife, battery-powered eraser, black fine-line waterproof marker, masking film, masking fluid

1 | Make the Stencil
Trace the background and strawberry onto a piece of masking film with a fine-line marker (see page 135). Don't trace any of the details. Indicate soft edges in the fabric with dotted lines.

To make repositioning the pieces easy later on, make short hash marks across each line. Remove the backing from the masking film and attach the film to your paper.

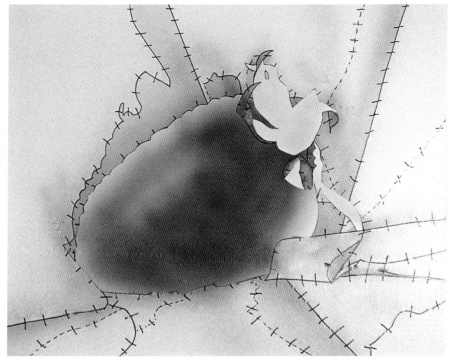

2 | Mask and Shadow; Add First Color

Cut the areas of background fabric out of the masking film using a sharp blade and light touch.

Mix equal amounts of Burnt Umber, Sap Green and Ultramarine, adding water to lighten the value. Airbrush the color onto the fabric shadows directing the spray to keep the area near the dotted lines soft. Let dry.

Replace the cut pieces of masking film to cover the fabric shadows you just painted. These are your lightest shadow areas. Do not cover your darker shadow areas of fabric with masking film.

Now cut the masking film from the darkest areas of the leaves. Spray one or more layers of color over the unmasked areas of the fabric shadows and the leaves to create your darkest shadow areas. Let dry and replace the cut masking film on the leaves and fabric.

Then remove the film from the strawberry. Apply masking fluid to the highlights of the strawberry. Mix equal parts of Quinacridone Magenta and Permanent Red. Spray with short bursts to give the color a mottled look. Create soft edges on the lower right and upper left by directing the spray so it doesn't touch the edge of the stencil. Let dry.

3 | Add Yellow

Remove film pieces from the lightest areas of leaves. Mix Hansa Yellow Light and Yellow Ochre and apply bursts of color for a dappled effect on leaves and strawberry. Let dry.

4 | Enrich the Red

Replace film pieces on the leaves. Airbrush Indian Red on the strawberry. The previous layers will show through and contribute to the final red. Let dry.

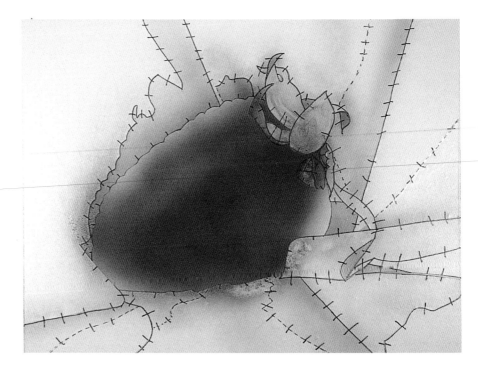

5 | Add the Details

Carefully remove all the masking film pieces and masking fluid with an art knife. Don't rub the masking fluid off with your fingers because it will mar the red watercolor of the strawberry.

Use a battery-powered eraser to make the seeds. Indicate every seed even if some will later be colored a darker value with colored pencil.

Develop the leaves with Indigo Blue, Rioja, Gray Green, Apple Green and Peacock Blue colored pencils. The added color and value will bring them forward.

Refine the fabric shadows with Grey Green.

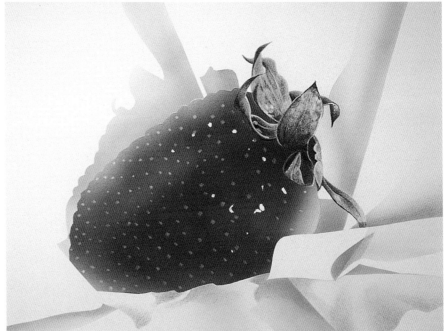

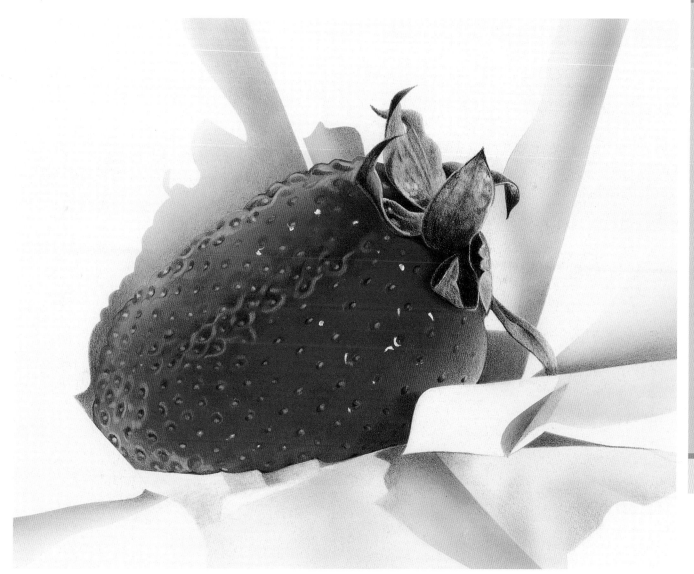

6 | Complete the Details With Colored Pencil

Apply White heavily along the left side and bottom of the strawberry to indicate the reflection of the fabric in its surface. You can create additional small highlights by lifting color with an art knife. Indicate the darkest areas of the strawberry with Rioja. Color the brighter areas with Poppy Red.

Define each seed by coloring the surrounding indentation with Rioja or Indigo Blue.

Apply Jasmine over the lightest areas of the leaves.

Use French Grey 50%, Cedar Green and Rioja to punch up the darker shadows in the fabric.

Enhance the mid-value areas of the fabric with Grey Green.

LUSH LIFE | Barbara Benedetti Newton, CPSA | 8" x 10" (20cm x 25cm) | Colored pencil and watercolor on 140-lb. (300gsm) hot-pressed watercolor paper | Collection of the artist

Layers of Color Illuminate the Landscape

This glorious moment at the end of the day gives tribute to Sue's ability to express the beauty she sees in nature. Color bursts from the setting sun and paints its way into the gradually darkening sky.

Sue has developed a technique that enables her to apply vibrant pencil colors one over the other by means of misted-on solvent. She begins with sanded pastel paper, establishes a foundation with Nupastels, then applies a full palette of pencil colors in glazes to create glowing landscapes illumined with a touch of radiance from sun or moonlight.

DAY'S END | Susan L. Brooks, CPSA | 11" x 16"
(28cm x 41cm) | Colored pencil, pastel and solvent on
sanded pastel paper | Collection of the artist

Dissolved Pigment Helps Portray Depth

Distinctive style and symbolic references mark this nonobjective work, indicating that Vera is truly in touch with the medium. The intriguing tension created by the shapes and colors gives the piece great visual strength. Warm colors dominate, with subtle changes producing the illusion of depth. This painting invites the viewer to have a closer look and holds our attention as we become absorbed in the details and creative use of media.

Heavily applied dry pigment is smeared and blended with cotton pads, sponges and swabs moistened with mineral spirits. Vera then searched for patterns and shapes that she defined or subdued with dry colored pencils and an electric eraser.

RUST ON ONE'S LAURELS | Vera Curnow, CPSA |
20" x 15" (51cm x 38cm) | Colored pencil, Art Stix and
solvent on cold-pressed illustration board | Collection
of Phil and Mary Ann Beckwith

Blended Pigment Solidifies Form

This energetic piece was inspired by Jeffrey's assortment of colorful scarves that seemed to explode from the drawer when she opened it. First she mapped the line drawing with erasable colored pencils, then blocked in values using Prismacolor Black Grape. She protected the white areas from smudges by applying cutout shapes of masking film to them before applying layers of colored pencil to build form and value. Prismacolor Colorless Blender markers then smoothed and solidified the forms. After the masking film was removed, Jeffrey added colored pencil to the white areas to insure maximum contrast and sparkle in this unique observation of everyday objects.

PASSAGES | Jeffrey Smart Baisden, CPSA | 20" x 30" (51cm x 76cm) | Colored pencil and Colorless Blender markers on illustration board | Collection of the artist

Metallics Create Exquisite Effects

Carlynne produces works rich in color and metallic effects. She takes advantage of natural forms and uses a variety of media to create visually exciting abstracts that are more than just a representation of the world as we see it. Carlynne makes use of solvents to dissolve and move color. Oil pastels and metallics spark her paintings with interest while her focus is on the form and design of nature.

IMPULSE | Carlynne Hershberger, CPSA | 12" x 9" (30cm x 23cm) | Colored pencil, solvent and Rub 'n Buff on gray Canson Mi-Teintes paper | Collection of the artist

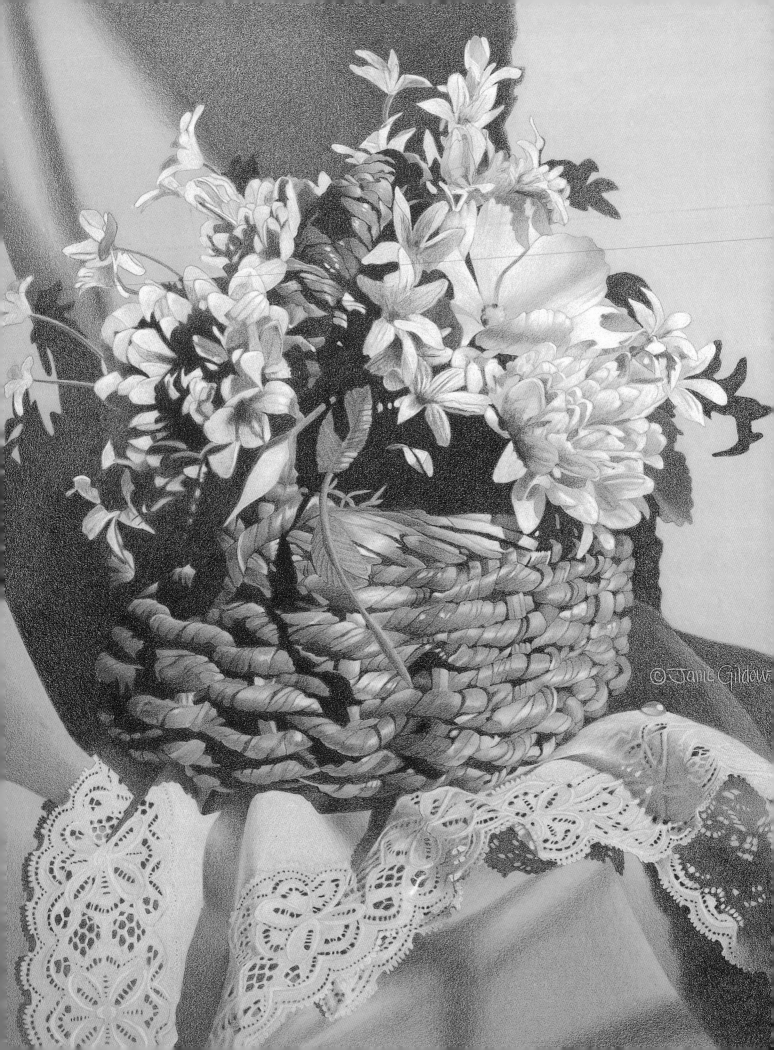

This chapter is your introduction to some strange and unusual companions for the colored pencil. This is where the sky is the limit. You'll be amazed at how some artists use colored pencil and just how they have adapted it to enhance their work. Experiment with some of the tantalizing methods these expert artists have invented for their personal expression. Try the unique surfaces they use. Learn their innovative techniques. Experience their inspiring results.

Maybe you only want to work in two dimensions. But maybe you want to try three. And now maybe you really are starting to think to yourself, "What if…." That's what this chapter is all about: getting you to use your imagination and start those creative juices flowing.

So wait no longer. Turn the page and enter the realm of anything goes!

CHAPTER FIVE

CREATIVE TECHNIQUES AND SURFACES
for Colored Pencil

LAVENDER AND LACE | Janie Gildow, CPSA | 13" x 10" (33cm x 25cm) | Colored pencil on sanded pastel paper | Collection of the artist

Demonstration | **Brülage**

LANDSCAPE | Laura Fisher, CPSA

Brülage, also called pyrography, is the process of burning or scorching with a tool to produce designs on a surface. In this exercise, you'll use an electric wood burner to create a variety of browned lines and areas on heavy museum board. The burned areas provide a depth of value unachievable with colored pencil alone. The incised texture and deep color create a dramatic contrast to the areas of pencil color.

Surface
4-ply white museum board or illustration board

Prismacolor Colored Pencils
Blue Slate, Bronze, Clay Rose, Cloud Blue, Goldenrod, Indigo Blue, Jasmine, Lavender, Limepeel, Marine Green, Peacock Blue, Sienna Brown, Sunburst Yellow, Tuscan Red

Other
Electric woodburning pen (available at craft stores) with interchangeable tips: cone, flat leaf, round wedge (universal); graphite pencil

1 | Burn the Outlines
Draw the image on the museum board with a graphite pencil (see page 136). Use the cone-shaped tip of your woodburning pen to define and darken the lines. Varying the pressure and speed at which you move the tool will change the appearance of the line. Slower speed with heavier pressure will burn darker, deeper lines that tend to widen. Moving the tool at a faster speed with less pressure creates lighter brown incised lines.

2 | Develop the Darks
Create the large dark areas of the composition such as those around the bases of the rocks and the shadows on the trees with your woodburning pen's round wedge (universal) tip. By using the side of the tip, you can burn large areas quickly and consistently. Change the angle at which you hold the tool to create interesting and varying textures and patterns in the burned areas.

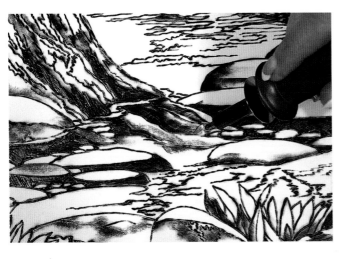

3 | Soften the Burn
Use the flat leaf-shaped tip of your woodburning pen for softer areas of brown. Unlike the areas burned by the first two tips, these areas are not deeply recessed into the surface of the board and will accept colored pencil. The soft brown can act as a color and value base for the layers of colored pencil that will be applied over it or it can stand alone.

4 Add Colored Pencil

Layer Jasmine on the rocks as a warm color base. Leave the tops of the rocks above the water line white. Add areas of Lavender, Blue Slate and Sunburst Yellow over the Jasmine to create variety and depth.

Develop darker areas with Tuscan Red and Indigo Blue. Blend the mix into the burnt areas of shadow on both the rocks and the trees to create a smooth transition into the dark.

Layer a base of Clay Rose on the trees; then add Bronze and Sienna Brown to create the bark pattern.

Over the Jasmine on the submerged rocks, layer varying amounts of Limepeel, Bronze, Marine Green, Sienna Brown and Goldenrod.

Create the open areas of water with Cloud Blue, Blue Slate, Bronze, Marine Green, Peacock Blue and Indigo Blue.

To maintain the illusion of a water line, leave the narrow line that appears and disappears around the shoreline white.

5 Burnish and Re-Apply Color

Burnish the water and the submerged rocks and plants with the lightest color used in the layering process. Relayer the other colors from that area on top of the burnished surface to optimize intensity and reestablish the color variations. Don't burnish the perimeter and surface rocks or the trees. By leaving those areas unburnished, you will maintain their texture and create a contrast between them and the burnished areas.

ALONG THE MEDINA | Laura Fisher, CPSA |
11" x 14" (28cm x 36cm) | Colored pencil and
brûlage on museum board | Collection of the artist

Demonstration | **Graphite**

LANDSCAPE | Allan Servoss, CPSA

In this exercise, you'll establish all values with a graphite pencil (grisaille, see page 22), then apply color over the tonal drawing with colored pencils. The colored pencil, being partially transparent, allows the graphite tones to show through it. In this way, you can create value changes with the application of just one color. If you are unsure about color value and contrast, this method makes it easy. The addition of color is not at all confusing, since you have already established the values.

Surface
Rag Mat 100 4-ply no. 1153 White

Prismacolor Colored Pencils
Cream

Polychromos Colored Pencils
Orange Light, Vermilion, Wine Red

Fullcolor Colored Pencils
Mauve, Prussian Blue

Other
2H or H graphite pencil

1 | Complete the Drawing With Graphite
Transfer the line drawing to your paper (see page 135). Use the graphite pencil to establish all the values and details. The harder lead won't smear as easily as softer lead and gives a more silvery appearance to the underdrawing.

2 | Tone the Drawing
Apply a light layer of Cream to the entire drawing. The graphite will smear in places. If you want a sharper edge to your work, first spray the graphite underdrawing with fixative before you add any color.

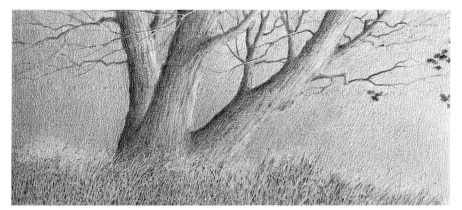

3 | Choose the Mood and Begin the Color

Layer Orange Light over the entire drawing. Reduce pressure in the grass and tree. Then layer Vermilion over the drawing in exactly the same way. In addition, reduce pressure toward the right side of the sky.

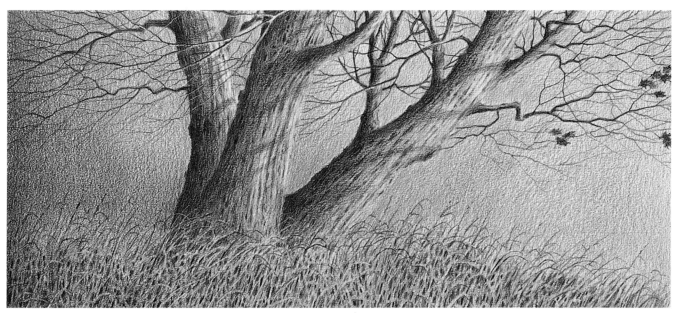

4 | Complete the Drawing

Intensify the negative areas and add contrast and shadows in the grass, tree trunk and limbs, and the few remaining leaves.

Add Wine Red to the sky, again reducing pressure toward the right side. Use Mauve and Prussian Blue to add color to the grass and tree.

LEANING TO OCTOBER | Allan Servoss, CPSA | 6" x 12" (15cm x 30cm) | Colored pencil and graphite on Rag Mat 100 4-ply no. 1153 White | Collection of the artist

Demonstration | **Textured Paper**

ABSTRACT DESIGN | Carlynne Hershberger, CPSA

Textured paper is a good foundation for abstract designs. The lines and textures are intriguing and reminiscent of natural forms. In this exercise crumpled paper provides random lines and shapes that catch and emphasize color. You'll apply colored pencil, blend and move color with solvent, augment with oil pastel and finally embellish your work with a metallic shimmer.

This exercise is abstract so your results won't be exactly the same as the example shown here.

Surface
Canson Mi-Teintes no. 470 Champagne paper

Prismacolor Colored Pencils
Aquamarine, Blue Violet, Burnt Ochre, Goldenrod, Light Aqua, Light Cerulean Blue, Sienna Brown, True Blue

Oil Pastels
Blue-violet, light aquamarine

Brushes
2 small throw-away brushes (foam or bristle), no. 2/0 round

Other
Copper leaf, cosmetic foam wedges, gold leaf adhesive size, gold leaf satin sealer, Pearl Ex Pigment (metallic powder) no. 681 Duo Blue-Green, Rub 'n Buff Autumn Gold

1 | Prepare the Paper

Soak both sides of the paper under running water. Let the excess run off and then wad it into a ball and give it a squeeze. Open it up and lay it flat to dry. While it's still wet, you can scrunch a specific area for added interest, but be careful not to tear the paper. It's much more delicate when it's wet. Let the paper dry completely. Don't worry about buckling; the paper will flatten as you work on it.

2 | Apply Colored Pencil

Look for a pattern of wrinkles and apply color to follow the pattern. Use firm pressure. Develop a focal point in the area of the tightest wrinkles. First apply Blue Violet to the focal point. Then work your way outward with colors in this order: True Blue, Light Cerulean Blue, Aquamarine.

In the surrounding areas, apply Goldenrod. It's not necessary to take the color all the way to the edge of the paper. Let the color of the paper work for the lightest values.

Over the Goldenrod, add a layer of Burnt Ochre. Add some Sienna Brown to deepen the value near the focal point.

As your pencil point grows dull, sharpen it so that the wood casing doesn't scratch the surface of the paper.

3 | Dissolve and Mix the Color

Dip the wide end of the foam cosmetic applicator in the solvent and squeeze out the excess. Begin in the areas where you applied the brown and gold. Use medium-to-firm pressure to dissolve and smear the color with the applicator. Then start to pull the color out toward the edge of the paper with the color-saturated applicator lightening pressure as you pull. As you skim the surface, your applicator will touch the highest ridges and still allow some of the bare paper to show.

With a clean foam applicator, repeat the process with the blues. First dissolve and smear the color, then start to lightly pull blue over the gold/brown mix, lessening pressure as you move away from the blue areas. The mix of complementary colors will produce beautiful muted tones. (See page 76-77 for information on working with solvent.)

4 | Find the Gems

Study the pattern that the wrinkles make. Is there one spot that's larger and smoother than the rest? Is there a cluster of small *gems*? Develop those areas as accents (lesser focal points). Working mainly in the blue area, use a Blue Violet or Aquamarine colored pencil to define and outline these shapes. Fill some of them in with color. Follow the grooves with your pencil to emphasize the cracks. Let the paper guide you.

5 | Add Oil Pastel

Use the side of the aquamarine oil pastel to rub color gently across the raised areas on the paper. You won't need to use much pressure because the oil pastel is soft and adds color quickly. If you press too hard, you'll deposit color where you don't want it. Do the same with the blue-violet oil pastel stick.

Begin to choose shapes and fill them with color using either the colored pencil or oil pastel.

6 | Build Bold Color

To build your light and dark values quickly use oil pastel. Use the tip of the blue-violet pastel to fill in the darkest value areas. Pick out the lights with the aquamarine oil pastel. Then layer the two colors together to create some middle values.

Want to make a change? You can still color over the pastel with colored pencil, or go light over dark, because the lead of the pencil is much harder than the oil pastel so it just pushes the color out of the way.

To further blend and smooth color, use a vinyl eraser.

7 | Paint With Copper Leaf and Rub 'n Buff

With a small brush apply a thin coat of adhesive size to the areas where you want to attach the copper leaf. Since you are working with random shapes, you don't have to worry about how the piece breaks. Drop the leaf onto the adhesive (you can use tweezers to place it where you want it) and tap it gently with your finger. Then use a soft brush to brush away the excess leaf. With another brush apply one coat of the sealer.

Squeeze a small amount of Rub 'n Buff metallic paste from the tube onto a dish or palette. Dip the no. 2/0 round brush into the mineral spirits and then into the paste. Mix until you have a smooth paintlike consistency. Once you have applied several layers of colored pencil and oil pastel, you can paint the metallic mix right over the color. Emphasize some of the lines by painting them with the metallic mix.

When the metallic lines are dry, buff them with a soft tissue to bring up the shine.

8 | Add Powder to the Metallic Mix

Use your fingers for this step. Squeeze a bit of Rub 'n Buff from the tube directly onto your fingers. Rub it across the peaks of the textured paper. Before it dries, open the jar of Pearl Ex Duo Blue-Green metallic powder. Dip another finger into the powder, tap to knock off the excess, then rub the powder on top of the applied Rub 'n Buff. Let some of the Rub 'n Buff show here and there for contrast. The resulting color and luminosity is exquisite. You can try this with other color combinations, too.

Evaluate your painting and, if necessary, reapply colored pencil to punch up color where you need it. The area of the most contrast should be your focal point.

If you are unhappy with any effect you produce, just use your electric or battery-powered eraser to remove it, even the copper leaf.

PETROGRAPHIC DAYDREAM #10 | Carlynne Hershberger, CPSA | 12" x 19" (30cm x 48cm) | Colored pencil and mixed media on Canson Mi Teintes no. 470 Champagne paper | Collection of the artist

Demonstration | Velour Paper

IRIS | Janie Gildow, CPSA

Sometimes you just feel like making softer, less distinct edges. Velour paper, also called Suedeboard, is fuzzy and feels like velvet. It takes limited layers of colored pencil and discourages fine details. But it's great fun to work with and due to its unique nature accepts pencil very quickly.

In this exercise, you'll use a limited palette of colored pencils to create the soft petals and smooth leaves of a lavender iris. The gray paper provides the mid tone; you add the darks and lights and blend the color.

You'll need to layer lightly with strokes going mostly in the same direction. A blunt pencil point works better than a sharp one nearly everywhere but you can use a sharper point wherever you want a cleaner edge.

Surface
Warm gray velour paper

Prismacolor Pencils
Dark Green, Goldenrod, Grass Green, Indigo Blue, Light Green, Sand, Sienna Brown, Violet, Violet Blue, White, Yellow Chartreuse

1 Start With the Lightest Values

Using a light box or a window, place a line drawing of the iris under the velour paper and trace the lines directly on the velour paper with Indigo Blue (see page 136).

Use White to indicate the lightest values on the petals. Apply heavier pressure in the lightest areas and less pressure toward the middle-value areas.

To start the leaf edges, stems and bud, apply a layer of Light Green. Then, in the same manner, apply a layer of Yellow Chartreuse.

Color the darkest part of the iris's fuzzy center with Sienna Brown, the lightest with Sand, and the middle with Goldenrod.

2 Add More Color

Vary pressure as you apply Violet Blue to the edges of the petals. Press harder along the edges and gradually decrease pressure with short strokes toward the center of the petal. Keep strokes going in generally the same direction, but you can use cross strokes where you need them to build up color.

Continue with the Violet Blue to begin the dark centers of the leaves and to show the contours of the stems and bud. Apply the color with a flattened blunt point. Keep your strokes light to apply color evenly.

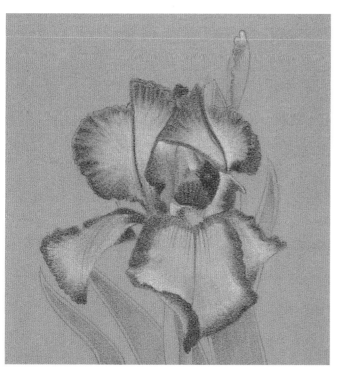

3 | Complete the Petals

To the same areas and in the same manner as you applied the Violet Blue in step 2, apply Violet to the petals. Again, keep edges sharp but lighten pressure and feather your strokes as you extend them slightly into the White.

Now, with very light pressure and a flattened pencil point, begin to add the soft contours to the middle of the petals using Violet.

Begin to suggest the fine vein lines on the petals with Violet Blue sharpened to a point.

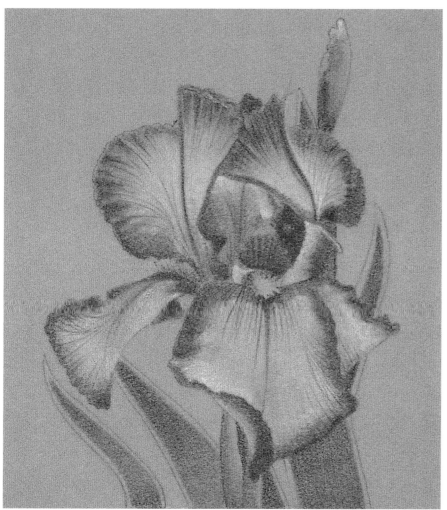

4 | Finish the Leaves

Finish the leaf centers, stems and bud by applying a layer of Dark Green over the already-applied Violet Blue. Follow with a layer of Grass Green in exactly the same manner.

LOYALTY | Janie Gildow, CPSA | 6" x 7" (15cm x 18cm) | Colored pencil on gray velour paper | Collection of Gertrude Luce

Demonstration | **Plastic Vellum**

APPLE | Danute E. Nitecki

Working on plastic vellum lets you create unique and colorful images and, at the same time, saves you the time-consuming labor of filling in the background with colored pencil.

In this exercise, you'll manipulate watercolor on vellum to create a colorful background, then lift some of the dried color from the vellum.

You'll apply colored pencil to the lifted areas and also directly on the dried color for a very unique effect.

Because you will be manipulating wet color to complete this exercise, the process will have varied results and your background will not be the same as the example.

Prepare Your Work Area

Cover your work area with plastic; the pouring process is messy. Place the vellum sheet on the white-covered board so that you can see the colors clearly during the pouring. Don't tape or staple the sheet because it needs to move and tilt freely as you mix.

Wet the Vellum and Apply Color

Wet the vellum sparingly, but evenly, with a large soft brush. Drip or pour Green Gold, Winsor Green and Burnt Sienna on the wet surface; tilt and rock the vellum to mix the colors. When you are satisfied with the effects you have produced, place the vellum on a board at a slight angle and allow the paint to dry completely.

Painted vellum dries slower than painted paper. Don't hurry the process and don't use a hair dryer. Once the paint dries, proceed with the following steps.

Surface
Plastic vellum

Brush
Any soft synthetic or bristle round

Winsor & Newton Watercolors
(mixed with enough water to be pourable)
Burnt Sienna, Green Gold, Winsor Green (Yellow Shade)

Prismacolor Pencils
Magenta, Marine Green, Pale Vermilion, Yellow Chartreuse

Other
Kneaded eraser, large board or piece of foamboard covered with a white plastic trashcan liner, paper towels

1 Lift Color
Place the line drawing (see page 137) under the vellum and use a soft wet brush to remove the watercolor in the area of the apple. It's like painting in reverse. Wet the brush with clean water and blot it on a paper towel; wet the colored surface with the brush in the area where you want to remove color. The water will immediately begin to loosen the dried color. Rewet and blot the brush as often as necessary to dissolve and remove the color. Repeat the procedure until the area is free of color.

2 | Outline Your Subject

Use the Magenta colored pencil to outline the leaf and stem. If necessary, use a kneaded eraser. Any other kind of eraser will remove the vellum's slight tooth, leaving a slick surface that won't accept colored pencil.

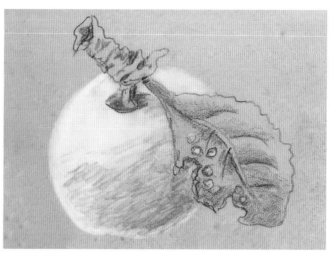

3 | Build Value

Lay in the shadows on the apple, stem and leaf with Magenta.

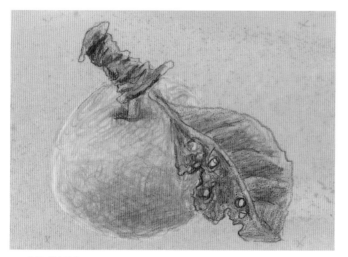

4 | Build Color

Add a layer of Pale Vermilion over the entire image as local color.

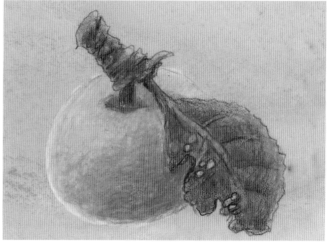

5 | Punch Up Color

Add a light layer of Marine Green to the stem and leaf. Layer Yellow Chartreuse over the entire image: leaf, stem and apple.

APPLE DEMO | Danute E. Nitecki | 6" x 6" (15cm x 15cm) | Colored pencil and watercolor on plastic vellum | Collection of the artist

Demonstration | Mylar

STILL LIFE | Robert E. Guthrie, CPSA

Mylar is a durable transparent plastic film with a matte finish on one or both sides that was originally made for draftsmen and engineers. It is available in various thicknesses.

Since it is the process that is important in this exercise, rather than trying to complete the entire drawing, you might want to work with a single object, or small group of objects, and concentrate on your application of pencil to the Mylar surface. At first it will take some practice to determine the right amount of pencil pressure to use. Working from light to dark is best, applying the lightest value colors first and the darkest last.

Burnishing doesn't work well on this material so use light applications of color. Practice to find the ideal pressure to use.

On this surface, wax bloom won't develop and colored pencil will not smear so using a fixative is not necessary. In fact, if you apply a fixative, the colored pencil wax will smear, or even run, while the fixative is wet.

Surface
5 mil Grafix Mylar (matte on both sides)

Prismacolor pencils
Cool Gray 30%, Cool Grey 50%, Cool Grey 70%, Dark Brown, Dark Umber, Indigo Blue, Light Cerulean Blue, Light Umber, Orange, Poppy Red, Sand, Sienna Brown, Terra Cotta, True Blue, Warm Grey 30%, Warm Grey 50%, Warm Grey 70%, Yellowed Orange

Other
Graphite pencil, kneaded eraser, tracing paper

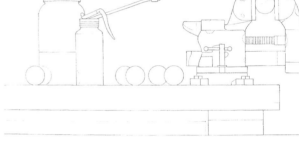

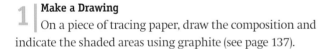

1 | Make a Drawing
On a piece of tracing paper, draw the composition and indicate the shaded areas using graphite (see page 137).

2 | Trace the Outlines
Place the graphite drawing under a clean piece of tracing paper and redraw the lines on the tracing paper with Poppy Red pencil so that they will be easier to see as you apply the gray values in the next step.

3 | Create the Values
Turn the red outline drawing over so that the image is backward and place it under a piece of Mylar. You'll be able to see the red lines through the Mylar.

Now start working on what will eventually be the back of your picture. Following the lines of the reversed image, develop a value study with all the warm and cool grays on the surface of the Mylar. In the areas that will be cool colors in the finished drawing, use the cool grays. Apply the warm grays where the warm colors will be. If you need to erase use a kneaded eraser. Other types of erasers will make the Mylar slick and it will not accept colored pencil.

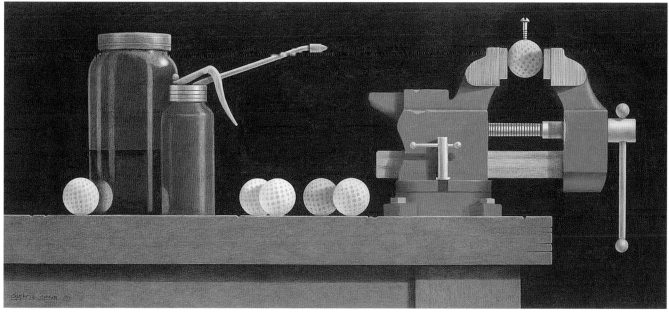

4 | Apply the Colors

Turn the Mylar over so that the gray values are on the back. Now you'll work on the front (the image will be right-side forward). Use color on this side.

Always apply the lighter values first, working gradually to the darker ones. Use less pencil pressure when you apply the lighter colors so that the darker ones will blend well when they are placed on top.

Layer the orange golf balls applying Yellowed Orange and Orange over the entire ball, Sienna Brown in the shadows, and Sienna Brown and Dark Brown in the dimples. Layer the white golf balls using Cool Grey 30% in the shadows and Cool Grey 50% in the dimples.

Layer the vise using Light Cerulean Blue in the highlights, True Blue as the local color and Indigo Blue in the shadows. Layer the metal (screw, jaws, etc.) with Warm Grey 30%, Warm Grey 50% and Warm Grey 70%.

Layer the oil can with Light Umber, Sienna Brown, Terra Cotta and Dark Brown. Layer the jar with Light Umber, Dark Brown and Dark Umber, and use Sand in the highlights. Layer the table with Light Umber and Sienna Brown, and use Dark Umber in the shadows.

Use Dark Umber to color the entire background. At this point, it becomes easier to work on the piece if you turn it upside down. This way, the little flakes of wax that come off the pencil can be brushed off without sliding across the lighter areas where they can stick and become more difficult to remove.

CRIME AND PUNISHMENT | Robert Guthrie, CPSA | 9" x 21" (23cm x 53cm) |
Colored pencil on Mylar | Private collection

CREATIVE PAINTING IDEAS

Bob came up with the idea for this painting after he read about an old-time professional golfer who, after having a bad score in a tournament, would take his golf balls home and boil them on the stove or torture them in various other evil ways.

Demonstration | **Clayboard**

HIBISCUS | Janie Gildow, CPSA

Techniques and Surfaces for Colored Pencil

Clayboard is a unique surface that invites you to experiment. The board is coated with a claylike medium that takes liquid color very well. But its real distinction lies in its ability to handle sgraffito work. The fun is in layering color and then etching through the color to reveal the snowy white surface beneath. Add more color; then etch some more. The surface is very forgiving; it allows for reworking, and will stand up to fine sandpaper and steel wool, and even the electric or battery-powered eraser. Because the surface is so smooth, you'll find that adding a layer of fine grit roughs it up to accept colored pencil better.

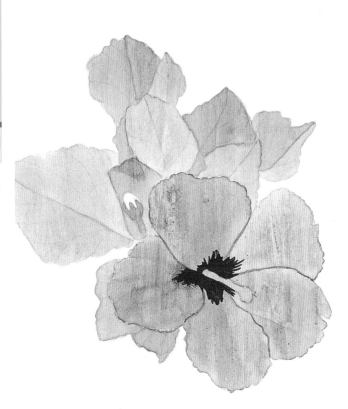

118

Surface
White Ampersand Claybord, smooth surface

Brushes
no. 4 flat, no. 5 round

Golden Liquid Acrylic
Hansa Yellow Light, Jenkins Green, Permanent Green Light, Quinacridone Red

Derwent Artist Colored Pencils
Geranium Lake, Madder Carmine, Mahogany, Midnight Blue, Moss Green, Olive Green, Phthalo Green, Rioja, Salmon, Sap Green, Terracotta

Other
Golden Acrylic Ground for pastel, scratch knife with pointed blade

1 | Prepare the Surface and Lay Initial Color

Thin approximately one teaspoon of the acrylic ground with water to the consistency of 2% milk. Use a no. 4 flat brush to apply the mixture smoothly and evenly over the entire surface of the piece of clayboard. Allow surface to dry completely. Transfer the line drawing to the dried surface (see page 137).

Make a thin glaze of acrylic by adding water to approximately four parts Quinacridone Red and one part Hansa Yellow Light. Use the round brush to apply the color to the blossom in two or three layers, building up color and allowing the color to dry between coats.

Make another thin glaze by adding water to approximately four parts Jenkins Green and one part Permanent Green Light. Apply this glaze to the leaves with the round brush. Leave some leaves light but add more layers to make others darker. Allow to dry between layers.

Paint the stamen yellow using a more concentrated mix of Hansa Yellow Light and a tiny bit of Quinacridone Red.

After the stamen is dry, add strokes of more concentrated red, mixed with a little yellow, at the throat of the flower with the round brush. Allow to dry completely.

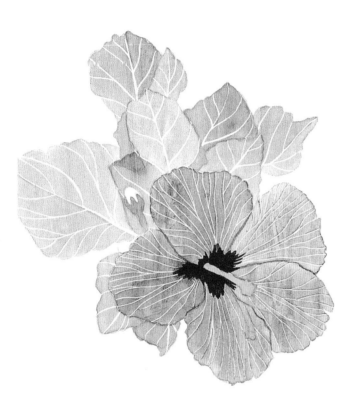

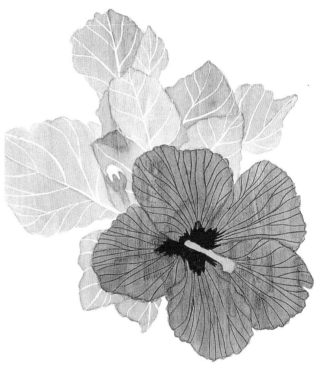

2 | Etch the Lines

Use the pointed blade of the scratch knife to etch veins in the leaves and on the blossom. As you scratch through the colored surface into the clayboard, the etched lines will reveal the snowy white clay beneath.

3 | Add More Color to the Blossom

With the less concentrated red/yellow mixture, tint the bud and re-tint the entire blossom, but not the stamen. As you apply the wash, the etched lines will darken as they soak up color. Leave the leaf veins white for now.

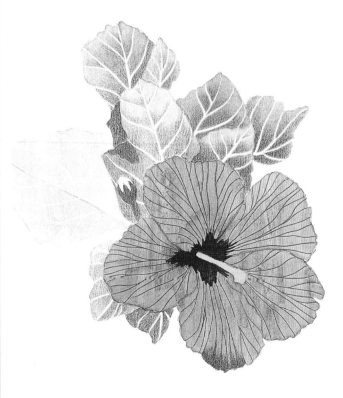

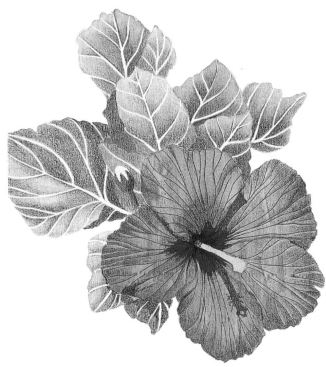

4 **Add Depth With Colored Pencil**
Apply the pencil delicately and evenly. Sharpen the point often as you work. Layer the color; don't burnish with heavy pressure.

Use the darker colors, Midnight Blue and Phthalo Green, to establish the darker parts of the leaves and the leaves that are in shadow. Leave the veins white. Then add the lighter greens, Moss Green and Olive Green, to the lighter value areas. Use Sap Green as a mid tone to blend the light and darker greens together. Here and there add touches of Terracotta to mellow the greens. Leave the lightest parts of some of the leaves alone to allow the acrylic wash to show.

Begin to darken the edges of the petals and the shadows with Mahogany and Madder Carmine.

5 **Define the Petals**
Continue to add Mahogany and Madder Carmine to all the petals. Use Rioja to even the color at the throat, and to add the dark value around the stamen and its cast shadow.

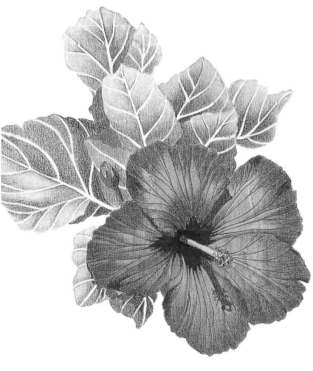

6 | Tighten the Color

Smooth and blend the darker colors at the edges of the petals with Geranium Lake, extending it toward the center of the blossom. Don't apply it to the lightest parts of the petals. Add the details to the stamen with Rioja and Midnight Blue.

Highlight the lightest parts of the petals with Salmon.

7 | Add the Sunshine With Acrylic Washes

Mix approximately three parts of Hansa Yellow Light acrylic to one part Quinacridone Red. Thin with water to make a light yellow-gold wash. Use the round brush to wash over the leaves and the white veins. As you apply the wash the brush will pick up some of the green pencil and add it to the color of the wash. If the wash becomes too green, blot the brush on a paper towel before reloading it.

Last, add enough water to the yellow/red acrylic mixture to thin it to a pale wash. Brush the wash on just the outer edge of each petal (not on the Salmon) and on the bud to add a little sunshine.

PINK HIBISCUS | Janie Gildow, CPSA | 5" x 7"
(13cm x 18cm) | Colored pencil and acrylic on prepared clayboard | Collection of Gertrude Luce

Demonstration | Polymer Clay

MASK | Carol Tomasik, CPSA

While it may seem incongruous to combine sculpture and drawing, in this demonstration you will do just that using polymer clay. Polymer clay is soft to work with and very forgiving of mistakes. It can be reworked endlessly until you get exactly what you want. It won't dry out or harden until it's cured in a home oven. (You can find additional information on working with polymer clay in *The Polymer Clay Techniques Book* by Sue Heaser, North Light Books, 1999.)

Experiment with the clay. Don't feel you have to create the mask shown in this demonstration. Just have fun adding colored pencil onto this unusual surface, and see where it takes you.

Surface
3 packages tan-colored Sculpey III modeling compound (polymer clay), Crescent regular mat board

Brushes
Small round

Delta Ceramcoat Acrylic Paint
Ivory, Mallard Green

Prismacolor Colored Pencils
Aquamarine, Black Grape, Blue Violet Lake, Bronze, Cloud Blue, Cool Grey 10%, Cool Grey 50%, Deco Aqua, Greyed Lavender, Jade Green, Light Peach, Light Umber, Pink Rose, Periwinkle, Sand, Sienna Brown, Slate Grey

Other
Clay modeling tool, craft glue, Jacquard Pearl-Ex powdered pigment (Sunset Gold)

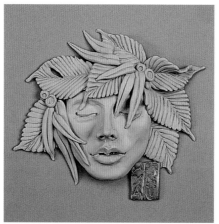

1 Sculpt Your Subject
Form the clay into a subject that appeals to you. Carole made a face and embellished it with leaves of different sizes. She created a gold seal for the lower right by impressing a small square of clay with a rubber stamp of Chinese characters. She used a small, dry brush to apply Pearl-Ex powder to give the seal a metallic appearance.

Once you've completed your sculpture, put it on a scrap of cardboard and bake it in your home oven at 250°F (121°C) for thirty minutes.

2 Apply a Wash
Allow the sculpture to cool completely. Mix a small amount of acrylic paint to add a base color to your clay piece. Try Mallard Green mixed with Ivory to make a pale green. Add enough water to make a very thin mixture. Paint this onto the clay piece using a small brush. Immediately wipe off the excess with a damp cloth. The wash will pool in the depressions and the color will be more concentrated in those areas. Let this wash dry.

3 Tint the Clay With Colored Pencil
You can add more color to your piece with colored pencil. Apply a light layer of Greyed Lavender to the higher surfaces of the clay (the leaves are colored here). Add a little Periwinkle to the shadowy areas. For just a hint of color, apply the pencil with a light delicate touch and use random color for variety.

4 | Weave Color on the Mat

To better display your clay piece, cut a mat with an opening large enough to accommodate the piece. Begin to tone the mat with colored pencil using short, parallel hatch marks. If you've been following Carole's color scheme, start with Jade Green, followed by Bronze, Light Umber and Cool Grey 50%, then layer the remaining colors as desired. Turn the mat board often to achieve a crosshatch effect. Add colors randomly, but keep darks together and lights together. The more crosshatch layers you apply, the tighter the texture will become. The trick is to keep your pencils very sharp and to turn the board frequently as you work. Carole added reeds within the background to give more depth and to tie the background in with her clay piece.

5 | Complete the Project

To add the last tint of color, apply Light Peach colored pencil as highlights (the cheeks, nose and lips are done here).

Support the finished clay piece with a cardboard backing toned in the same crosshatch manner as the mat with the cutout opening. Glue your clay piece onto the backing with ordinary craft glue. Position the backing with the glued clay piece so that the piece shows through the opening in the mat.

BLUE ASH | Carol Tomasik, CPSA | 16" x 14" (41cm x 36cm) | Colored pencil and polymer clay on matboard | Collection of the artist

Demonstration | **Rice Paper**

LEAVES | Allan Servoss, CPSA

This demonstration will help you create new and exciting textural effects with gesso, white tissue paper and Japanese rice paper as a base for watercolor and colored pencil. Go for a looser approach as you develop positive and negative areas with watercolor. The added advantage to this technique is that you can use it to cover old paintings you were just going to throw away.

Since Allan has a more abstract way of working, don't expect your work to exactly duplicate his. Instead, concentrate on developing positive and negative shapes in your own work and creating a center of interest with strong contrasts.

Surface
140-lb. (300gsm) cold-pressed watercolor paper

Polychromos Colored Pencils
Cadmium Lemon, Orange Light, Orange Yellow, Prussian Blue, Vermilion

Fullcolor Colored Pencils
Cobalt Blue, Mauve

Derwent Artists Colored Pencil
White

Brush
Medium round

Holbein Watercolor
Burnt Sienna, Cadmium Red Medium, Cadmium Yellow Medium, Cobalt Blue, Mauve

Other
Acrylic matte varnish, gesso, Imperial Kinwashi Japanese rice paper, white tissue paper

1 | Build the Surface
Partially cover your surface with gesso. Allan used an old, unwanted painting as his surface. While the gesso is still wet, lay torn pieces of white tissue and rice paper on the surface. When you have arranged the torn pieces to your satisfaction, apply a coat of matte varnish to the entire surface. Set it aside and allow it to dry completely.

2 | Establish Negative and Positive Areas With Watercolor
Use a medium round brush to apply mixtures of Ultramarine Blue and Cadmium Red Medium to the torn paper surface. Push and pull values by developing negative areas and isolating positive ones.

3 | Establish the Major Components
Rough in the lights, darks, midtones and shape/angle relationships with Cobalt Blue, Burnt Sienna and Cadmium Yellow Medium.Vary the amount of water you mix with each color to provide variation to your range of values.

4 | Introduce Colored Pencil
Add color to the leaves with colored pencil; first with Cadmium Lemon, then with Orange Light, Orange Yellow and Vermilion. Layer Cobalt Blue on the twigs and branch areas. Add Mauve and Prussian Blue to some of the dark (negative) areas.

5 | Complete the Piece
Develop contrast and contour by working with White pencil over all areas. Use it to add highlights to the leaves, twigs and branches. Then use Cobalt Blue and Mauve to enhance the shadow areas and suggest the roundness of the branches.

Sharpen and define the values by making any adjustments necessary to the light, midtone and dark areas so that they are clearly delineated. Apply more White to the highlights for additional definition in those areas.

THE LEAVES ARE BROWN AND SOBER |
Allan Servoss, CPSA | 11" x 15" (28cm x 38cm) | Colored pencil, watercolor and mixed media on 140-lb. (300gsm) cold-pressed watercolor paper | Collection of the artist

Intriguing Circles Develop Soft Value Changes

Maggie's work needs no introduction. She is well-known for her use of the self-developed technique she calls *Circulism*. Her images grow on toned pastel paper, clayboard or specially prepared wood by means of the thousands of overlapping circles that she applies in layer after layer of color. Maggie works exclusively with colored pencil and always on a colored or toned ground. To apply the pencil, she begins with the lighter colors, then carefully builds the darker values and finally the midtones. The nature and size of the area or object determines the size of the circles she will make. Her unique application and her use of color generate works rich in hue and subtle nuances.

IN THE MIDDLE | Maggie Toole, CPSA | 24" x 36"
(61cm x 91cm) | Colored pencil on clayboard | Private
collection

Combining Fabric With Colored Pencil Is a Tactile Experience

Linda actually quilts small blocks of fabric that she then sews (with a sewing machine) onto drawing paper. The blocks are backed with Pellon fusible interfacing and muslin, and taped (from the back) into the openings in the paper.

Linda makes a basic line drawing to delineate the major edges or shapes, then *quilts* the fabric squares to the paper, continuing some of the stitching out onto the paper. She completes the colored pencil drawing by blending and matching some of the colors from the fabrics to camouflage the fabric edges. She takes her cues from the fabric designs and extends the patterns or variations of them onto the paper. To complete the composition, she masks the fabric blocks before spraying the piece with Krylon UV-Resistant matte finish. Linda's love of plant, leaf and flower forms is evident in this visually exciting piece that is rich in textural contrasts.

AUTUMN PURPLE | Linda Henize, CPSA | 24" x 16"
(61cm x 41cm) | Colored pencil and fabric on 80-lb.
(180gsm) drawing paper | Collection of Mr. and Mrs.
Fred Henize

A Variety of Special Effects Creates Interest

Jerry's resourceful encounter with a variety of materials and media produced this innovative collection of visual images and intriguing qualities. In a refreshing move from the traditional into the unique, he incorporates overlapping shapes and creative color changes to give depth and dimension to this vigorous composition. His skillful blending of hard-edged shapes and numbers with painterly effects on this distinctive surface makes this piece a success.

THE BONDAGE OF REFLECTIVE, RETRO-SPECTIVE CONTEMPLATION #1 | Jerry L. Baker, Jr. | 10" x 13" (25cm x 33cm) | Colored pencil, watercolor, gold leaf, Letraset dry-transfer letters and ink on clayboard | Collection of Mary Davis

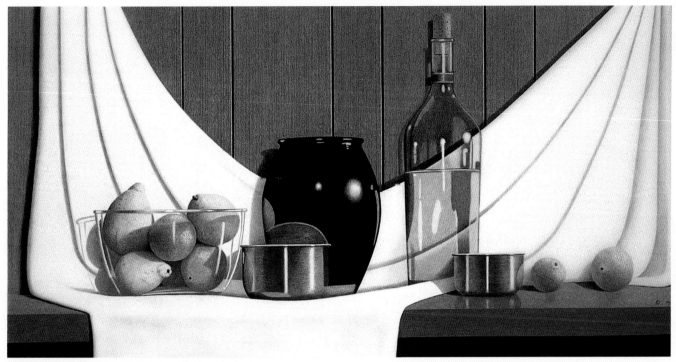

Mylar Helps in Achieving a Strong Value Drawing

Bob puts colored pencil to Mylar to create harmonious color with a rich satin finish. His unique arrangement of everyday objects, his control of color and value added to his ability to create strong compositions, all demonstrate his mastery of this technique and medium.

First Bob uses a series of gray colored pencils to establish a complete value drawing on the back of the Mylar film. Then he turns the film over and, with colored pencils, builds color on the front. The shades of gray applied on the back show through the film, lending contour and volume to the color.

SWEET & SOUR | Robert Guthrie, CPSA | 15" x 30" (38cm x 76cm) | Colored pencil on Mylar | Private collection

The Surface Helps Portray the Subject

This soft delicate piece was created with images on two superimposed polyester sheets. It is an elegant expression of floral grace and charm. The repetition of shapes suggests the movement of fragile blossoms dancing in the spring breeze. Watercolor mixtures tint the plastic film to build depth and color. In the lightest areas, color is lifted from the surface to create the dainty gossamer effect. Colored pencil adds a touch of delicate detail to complete this lovely vision.

NARCISSUS VISION | Danute E. Nitecki | 11" x 16" (28cm x 41cm) | Colored pencil and watercolor on plastic vellum | Collection of Ms. Pat Barkas

A Unique Surface Permits an Extreme Range of Values

The clear glorious light of morning is captured in this exquisite cactus blossom. The emphasis and contrast created by the rich dark background showcases the multipetaled bloom. The subtle touches of the needles add a quiet interest to the background as they lead our eye directly to the focal point in the center of the flower. Jane achieved the marvelous range of values by covering the background with Dark Umber and Black colored pencils. To smooth and intensify the color, she applied rubber cement thinner to the heavy layers of pencil with a small brush. Her handling of the medium and surface is absolutely brilliant. This piece is a magnificent statement of light, contrast and color.

MORNING LIGHT | Jane McCreary | 18" x 13" (46cm x 33cm) | Colored pencil on Sage Green Windberg Marble Dust paper | Collection of the artist

Gourd Surface Accepts Colored Pencil Easily

Rather than using paper or canvas, Karen chooses to work on a gourd surface. The quality of her work immediately distinguishes her as a fine artist. Working on gourds she has cleaned and prepared herself, Karen transfers a line drawing to the surface, uses masking fluid to protect positive images and then applies leather dyes and/or shoe polish to tint and color the background. Once the medium is dry, it is buffed to a gloss. The mask is removed and the composition is completed with several applications of colored pencil to develop color and refine images.

AUTUMN GLOW | Karen Lilly | 6" x 7" (15cm x 18cm) | Colored pencil, woodburning and shoe polish on a dried gourd | Collection of Dave and Jan Glowacki

Specially Fired Clay Presents a Unique Surface for Embellishment

Sheila is a multitalented and multifaceted artist. She works in, and with, the third dimension and creates enchanting whimsical pieces embellished with luxurious touches of splendor. This little vase with its glaze of sumptuous color is made of raku-fired clay and adorned with rice paper and colored pencil. Sheila employs the metallic colors with tasteful flair and pizzazz. Her innovative use of colored pencil on raku fired clay has resulted in this unique, special and very personal expression.

SQUARE VASE | Sheila Giddens | 8" x 4" (20cm x 10cm) | Colored pencil and rice paper on raku-fired clay | Collection of the artist

Line Drawings for Demonstrations

These line drawings are for you. This book is not about drawing; it's about finding new ways to work with your colored pencils. You have permission to copy and enlarge these drawings for use in practicing the demonstrations in this book. Get creative with your colored pencils!

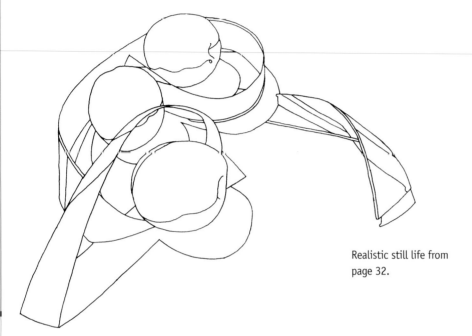

Realistic still life from page 32.

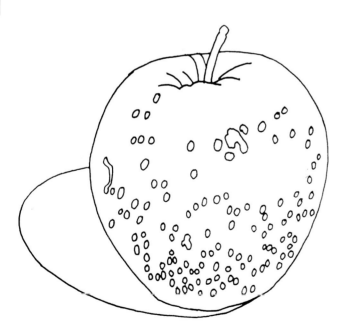

Granny Smith apple from page 42.

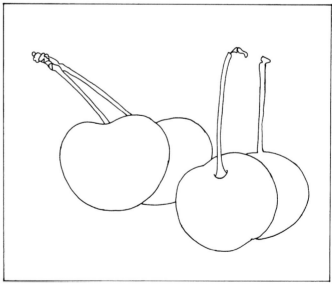

Cherries from page 44.

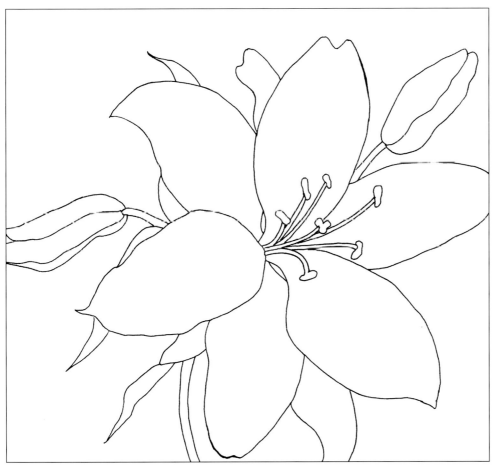

Lily from page 46.

Sweet cherries from page 60.

Red grapes from page 52.

Stylized landscape from page 64.

Plum and cherries from page 78.

Poodle from page 82.

Landscape from page 84.

Yellow pepper from page 90.

Strawberry from page 94.

Landscape from page 106.

Landscape from page 104.

Iris from page 112.

Still life from page 116.

Apple from page 114.

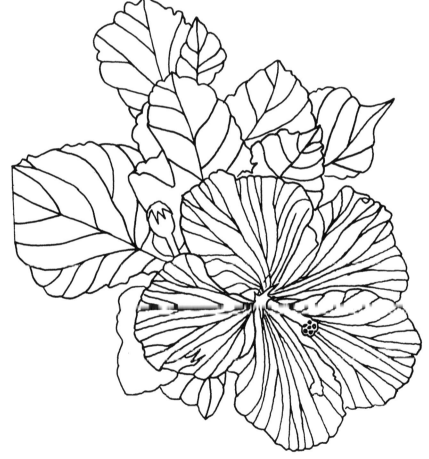

Hibiscus from page 118.

Susan L. Brooks, CPSA

Sue graduated in 1973 from the Ohio State University with a bachelor of fine art in painting, drawing and graphics, and received a bachelor of art education in 1975. She taught in public schools for several years and then worked in the high-tech industry for fifteen years.

Returning to art in 1992, she joined the Colored Pencil Society of America (CPSA), serving as Chicago Chapter president, National Exhibition director of the National Governing Board, and most recently as national president (a position she currently holds). She achieved Signature status at the CPSA International Exhibition in 1998. She teaches classes and workshops throughout the year.

Sue's work has been accepted into juried shows across the country, including the prestigious Salmagundi Show in New York. Her work has been published in *The Best of Colored Pencil 3* and *5* and *Floral Inspirations* (Rockport Books); and was featured in Gary Greene's *Creating Radiant Flowers in Colored Pencil* (North Light Books).

Laura Fisher, CPSA

Laura attended the San Francisco Academy of Art and worked as a creative director and graphic artist in California for fifteen years. She owned a design company in California for ten years. She currently resides in East Texas, devoting her talent, energy and professional skills to the creation and promotion of her art. She received a bachelor of fine art from Sam Houston State University and is currently pursuing a master's degree in painting.

Laura is a Signature member of the Colored Pencil Society of America (CPSA) and she demonstrates and teaches workshops in colored pencil. Her work has appeared in *American Artist* magazine and was featured in *The Best of Colored Pencil 5* (Rockport Books). She has participated and won awards in international, national and regional shows. Laura's work hangs in private collections throughout the United States.

Carlynne Hershberger, CPSA

Carlynne graduated from Central Florida College with a degree in fine art. From there she went to the Art Institute of Ft. Lauderdale.

She began using colored pencil twenty years ago. At the time, there was no instruction in the medium, so experimentation was her teacher. Since then she has become a Charter and Signature member of the Colored Pencil Society of America (CPSA) and president of the CPSA's Florida chapter.

Her award-winning work has been included in numerous international exhibitions and her paintings have been included in four of *The Best of Colored Pencil* books and in *Creative Colored Pencil* (Rockport Books).

Vera Curnow, CPSA

Vera is the founder of the Colored Pencil Society of America (CPSA). She has authored eight books (including Rockport Books' *Best of Colored Pencil* series, volumes 1-6) and has had her artwork published in several books and magazines (including *The Artist's Magazine* and *International Artist* magazines). A nationally award-winning artist, Vera has been featured in group and solo exhibitions. She serves as an art juror, and conducts workshops and lectures nationwide.

Robert Guthrie, CPSA

Robert is a self-taught artist. Early in his artistic career he worked as an abstractionist, but turned to realism in 1981. Shortly after that he began to develop his colored pencil technique.

Robert is a Signature member of the Colored Pencil Society of America (CPSA) and the Knickerbocker Art Society. His work has been featured in many books and publications, including *The Artist's Illustrated Encylopedia* and *The Complete Book of Colored Pencil* (North Light Books); *The Best of Colored Pencil 2, 3, 4* and *5* (Rockport Books); *The Artist's Magazine* and *Southwest Art* magazine.

Priscilla Humay, CPSA

Priscilla earned her bachelor of fine art from the School of the Art Institute of Chicago. She received her masters degree with concentration in printmaking, drawing and film animation from the Illinois Institute of Technology.

She toured Europe and was accepted at the Charles University's Print & Drawing Atelier in Prague, Czech Republic for post-graduate study.

Upon returning to the United States, Priscilla worked as co-director for ARC Gallery in Chicago. She has taught drawing at the College of Lake County in Illinois and has led critiques at various colleges and institutions. She is currently the public relations director on the National Board of the Colored Pencil Society of America (CPSA).

Priscilla's art has been represented nationwide in galleries and museums through major juried and invitational exhibitions. Her artwork hangs in many private and permanent corporate collections, including Kemper, Illinois Bell, Bauhaus Archive in Germany and the Chicago Historical Society.

Sueellen Ross

Sueellen has been a full-time professional artist for over twenty years. Her paintings, etchings and other prints have been exhibited worldwide. She is a frequent contributor to the prestigious Birds in Art show at Leigh Yawkey Woodson Art Museum in Wisconsin, and the Arts for the Parks show in Wyoming.

Her work can be seen in *The Best of Wildlife Art*, *Painting Birds Step by Step* (North Light Books), and in *Owls of North America* (Heliconnia Press, Inc.) She is the author of *Paint Radiant Realism in Watercolor, Ink & Colored Pencil* (North Light Books).

Allan Servoss, CPSA

Allan has worked extensively in colored pencil for years. His drawings have been exhibited widely and published in many books and publications, including all of the *Best of Colored Pencil* books and *Creative Colored Pencil* (Rockport Books), as well as *The Artist's Magazine*.

He is a Signature member of the Colored Pencil Society of America (CPSA) and has conducted numerous colored pencil workshops.

Barbara Benedetti Newton, CPSA

Barbara's formal art career began as a fashion illustrator. After a twenty-year sabbatical from art, she began creating fine art in colored pencil.

Barbara's work has been included in several books and publications, including *Best of Colored Pencil 1, 2, 3, 4* and *5* and *Creative Colored Pencil* (Rockport Books); *International Artist* magazine, *The Artist's Magazine* and *American Artist* to name a few. She is the co-author of the *Colored Pencil Solution Book* (North Light Books).

Barbara is a Charter member, Signature member and past president of the Colored Pencil Society of America (CPSA), and a juried member of the Catherine Lorillard Wolfe Art Club, New York City, and Women Painters of Washington.

Kristy A. Kutch, CPSA

Kristy is a graduate of Purdue University with a bachelor's and master's degree in education, as well as a license in teaching. She has taught colored pencil/water-soluble pencil workshops nationwide.

Kristy's work has appeared in many books and publications including *Best of Colored Pencil 1, 3* and *5* and *Creative Colored Pencil* (Rockport Books), *Creating Radiant Flowers in Colored Pencil* and *Exploring Color*, rev. (North Light Books) and *International Artist* magazine.

Dyanne Locati, CPSA

Education has played an important role in Dyanne's career. For five years she owned and operated the Locati Creative Art Center, which involved teaching and organizing workshops and classes in all media. She continues to teach a variety of classes and workshops, as well as jurying both colored pencil and mixed media art shows around the country.

Dyanne has served as president of the Watercolor Society of Oregon and president of the Colored Pencil Society of America (CPSA) District Chapter 201. For six years she served on the National Board of the CPSA as executive vice president and director of International Exhibitions.

Her artwork has been published in several colored pencil books and is included in many private and public collections.

Danute E. Nitecki

Danute was born in Lithuania and graduated from art school in Freiburg im Breigau, Germany, specializing in folk art and textiles. After immigrating to Chicago, Danute attended the University of Chicago, receiving a Ph. D. in Chemistry. She worked for twenty years in UCSF Medical School doing research in immunochemistry, eventually leaving UCSF to research biotechnology for a pharmaceutical firm. She has over one-hundred scientific publications and twenty patents.

Danute started drawing and painting again in 1987 for her own pleasure. Her work has been shown in many juried art exhibitions and has won many awards.

Carol Tomasik, CPSA

Carol graduated with a bachelors of fine art from Kent State University, with a concentration in painting and ceramics. She worked for ten years in the graphic design world as an art director. She also designed and painted silk clothing, exhibiting in local and national venues.

Carol has been a Signature member of the Colored Pencil Society of America (CPSA) since 1998. Carol is also a member of the National Polymer Clay Guild. Her work has been published in *The Best of Colored Pencil 4* and *5* (Rockport Books). She occasionally gives classes in drawing and polymer clay, and has won many awards in both mediums.

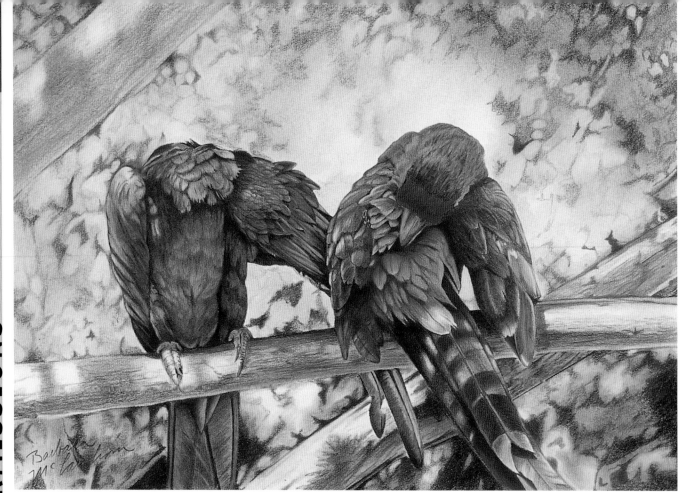

JUST A PICKIN' | Barbara McLawhorn | 11" x 15" (28cm x 38cm) | Colored pencil and pastel on Stonehenge paper | Collection of the artist

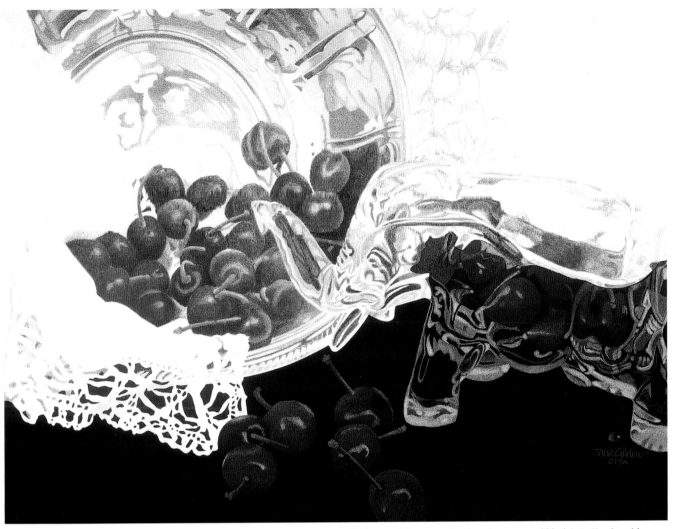

AVATAR | Janie Gildow, CPSA | 10" x 14" (25cm x 36cm) | Colored pencil on 140-lb. (300gsm) hot-pressed watercolor paper and black LetraMax board | Collection of the artist